Hyper Realistic Drawing

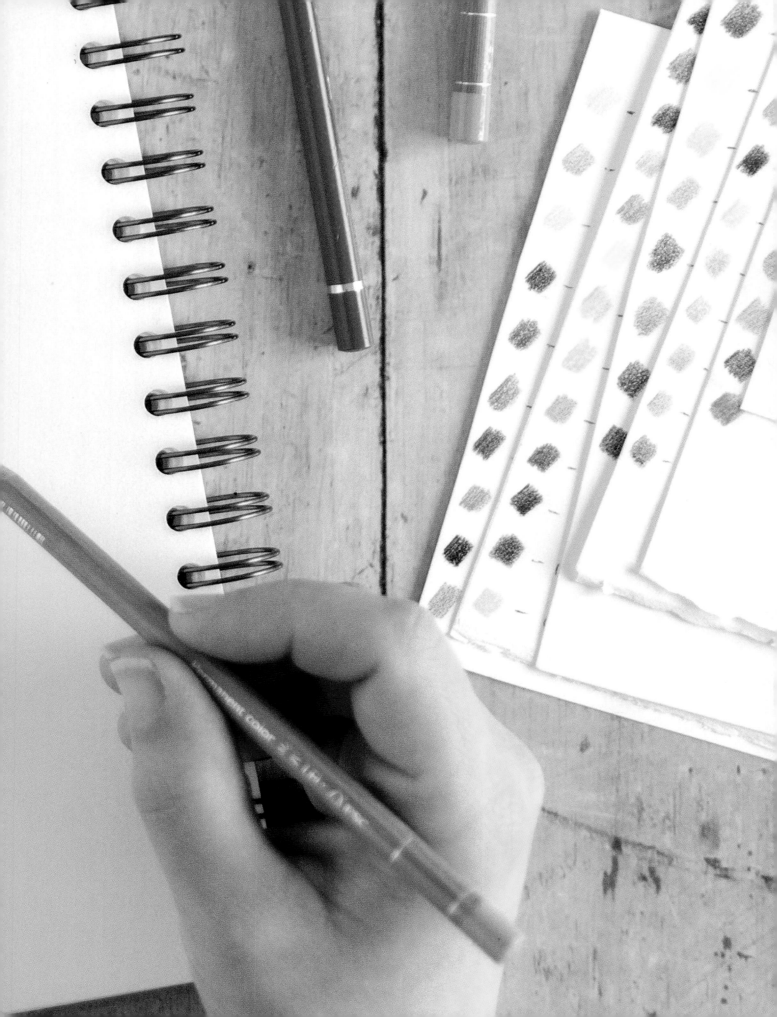

Hyper Realistic Drawing

CREATE PHOTOREALISTIC 3D ART
WITH COLOURED PENCILS

Amie Howard

DAVID & CHARLES

www.davidandcharles.com

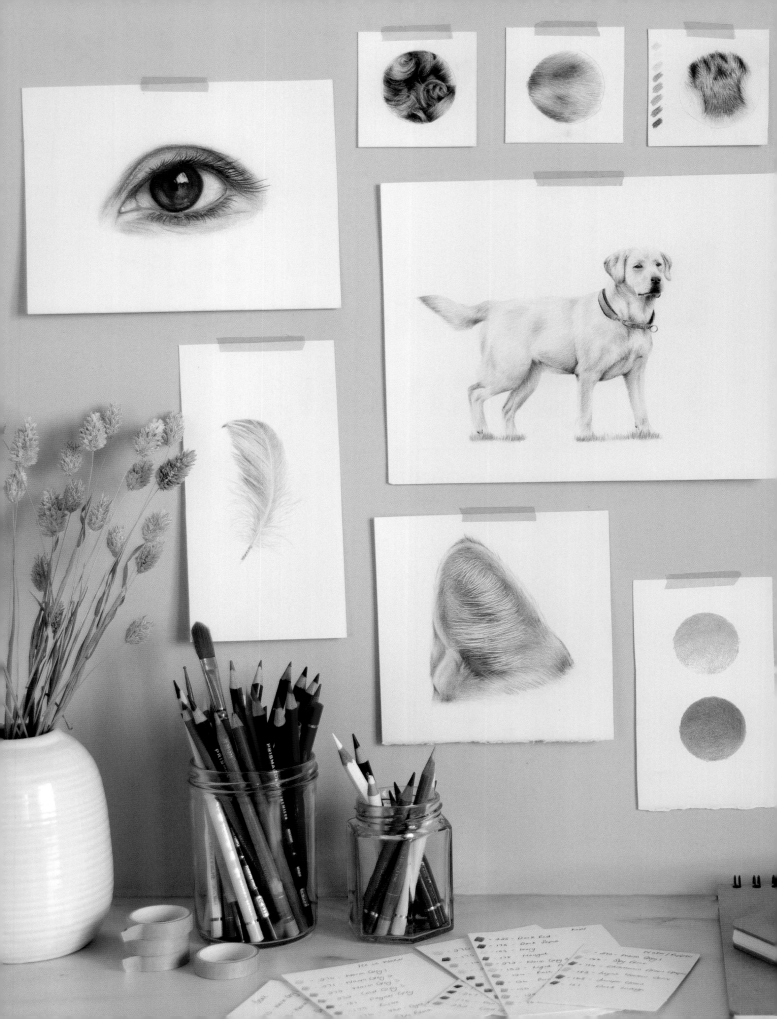

Contents

Introduction

Hyper realism is a fast-growing art form that focuses on taking photographs and objects and turning them into art that looks so realistic you could touch it! Basically, it means making art that looks like a photograph. For me, though, this way of working really focuses on the details of a piece and exaggerates them.

So why coloured pencils and hyper realism? Coloured pencils allow you a lot of control over details and there are so many ways you can apply them to gain realistic results. Details are essential to bringing a piece to life – which is the aim of hyper realism – so it's only natural that these two go hand in hand.

Coloured pencils are the perfect tool for creating realistic work. One thing I love about them is that there are so many ready-made colours available, so many shades of red, green and brown that you can use straightaway, but you can also blend the basic colours together to form your own colours. The possibilities are endless with coloured pencils by your side, and they're so easy to pack up and take on the move for a quick sketching session or to keep in your bag in case inspiration hits.

I fell in love with drawing with coloured pencils because of the things I was able to create quickly that were just not possible with other media like acrylic paints. I find I can confidently build up colour, make marks on my paper and express myself in a way that I just couldn't with other media. And there are so many different types, sets and colours to choose from, which we will look at in detail in the next few pages.

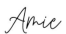

The Essentials

Your choice of pencils is a priority, but you'll also need some other equipment for coloured pencil work; from erasers and sharpeners to embossing tools and gel pens for highlights. Let's look at the basics.

PENCILS

There are so many coloured pencils to choose from, it can be hard deciding which to go for and what makes each brand or type different. One of the main variations is what the pigment is made from; whether they are wax or oil based. All coloured pencils contain a certain amount of wax and oil, but some contain higher percentages than others. Note that the colour names and codes given for the studies in this book are from the Faber-Castell Polychromos Artists' range.

WAX BASED OR OIL BASED?

What difference does this make? Well, if a pencil has more wax – and is referred to as wax based – it tends to be creamier and apply a thicker and stickier colour to your paper. These pencils blend and layer up quickly and tend to make your final drawing look really smooth. Wax-based pencils are great for base layers and creating smooth tone but there is one drawback to them, and that is that they do not hold a sharp point for long enough to add details to a piece. Due to their soft nature, they crumble with firm pressure, and it can be frustrating to keep sharpening them to get that point back.

What about oil-based pencils? These pencils contain more oil than their wax-based counterparts, they tend to be a lot harder and can hold a sharp point much better than wax-based pencils. Oil-based pencils layer up a little more slowly and gently and require a little more pressure to achieve a smooth look. They are perfect for adding details into your drawings as they perform better with pressure, which means you can get super sharp marks down on paper. They're also great for base layers, but as I mentioned, they do take a little longer to layer up and a little more effort than wax-based pencils, which is the only downside to them.

CAN YOU USE THEM TOGETHER?

Absolutely! I find that using a combination of both wax- and oil-based pencils is really beneficial. You get the best of both worlds: the wax for adding in base layers and getting the under and mid tones in and then the oil-based pencils for adding those really fine details over the top.

The key to using them together is to try not to layer up wax-based pencils too much, or exert too much pressure, otherwise the drawing surface becomes slick, and it can be difficult to add any details over the top. This happens due to the extremely waxy nature of the pencils. There are a few tricks you can use to eliminate this wax bloom; using a solvent is one option and we'll talk about that later.

EMBOSSING TOOL

These little tools are a handy addition to your equipment stash. They allow you to indent the paper to form a groove that the coloured pencil will just glide over when you shade over the top, leaving you with clean, white lines. This is particularly useful for details like whiskers, white hairs, or anything small that you want to keep clean and white. Use the embossing tool just like a pencil, putting pressure on it to indent the paper. Make sure you use enough pressure to form a deep groove, otherwise the pencil will just fill it up. See an embossing tool in action in the Cat's Ear project.

SOLVENTS

Solvents allow you to achieve a more 'painterly' look and help to blend and smooth coloured pencil. They also add vibrancy to drawings as they blend the pigments. Solvents come in two different forms: as bottled liquids (sometimes called odourless mineral spirits) or in blender pen applicators. The bottled variants can be applied with a paintbrush or something like a cotton bud. If you're using bottled blender, be careful with the amount you have on your applicator – too much and your pencil layers will end up looking mottled and patchy. Too little and the solvent won't work its magic.

The key to using solvents is having enough layers of coloured pencil down on paper before you use them – I suggest anywhere above four layers. Also remember to blend from your lightest sections to your darkest sections because the pigment moves around quite a bit and blending the other way can eliminate lighter tones. When blending a piece using solvents, you can put a lot more layers of pencil down, especially if you're using wax-based pencils, as the binder is dissolved into the paper more. This also helps get rid of wax bloom. Because of this effect, it's a lot easier to add white or lighter coloured pencils on top of dark.

FLUFFY BRUSH

A soft, fluffy brush, like a large watercolour mop, or even a dedicated drawing broom is an absolute must, as it allows you to brush away any build-up of pencil or eraser residue gently and effectively. You may think you can just brush debris away using your hand, but your hands contain oils that can damage and seep into the paper you're using and can also affect the longevity of your coloured pencil piece. Using a fluffy brush eliminates the risk of anything from your hand being introduced to your work that may affect it.

SCRAP PAPER

I always have a piece of scrap paper to hand for testing out colours, but also for leaning on while my hand is working over the drawing. If you rest your hand on your piece, you'll not only introduce oils, but you can also pick up and transfer coloured pencil residues. I've done this numerous times and, in the case of staining pigments, it's incredibly hard to erase from any white spaces of a drawing.

WHITE PENCIL

I use a white pencil a lot for blending as I find it's the best way to bring colours together. A white pencil is an essential piece of kit when working with coloured pencil, as you can use it not only for blending, but also as a replacement for an embossing tool. If you opt for a waxy white pencil, you can also use it to form a wax resist, as in the embossing tool technique, where coloured pencil layers will skip right over a heavy, waxy white layer.

WHITE GEL PEN

I sometimes use gel pens to add in white highlights that are difficult to add in other ways. A good, opaque white gel pen, like a Sakura Gelly Roll pen, is key and they can work over the darkest colours. Gel pen tends not to show up so well over lighter colours though, so a different approach is needed for those.

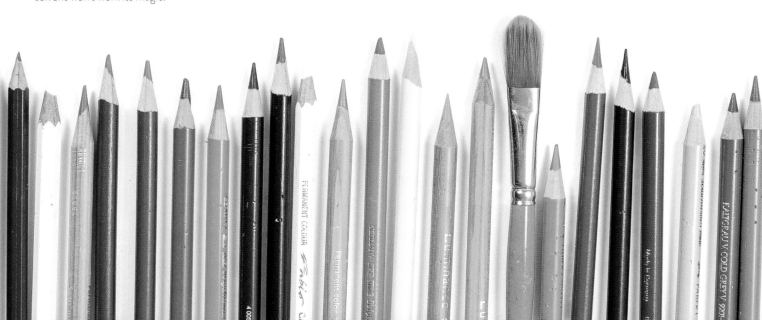

Paper

There are many different paper types and varieties to choose from and the right choice of paper is different for every person. For coloured pencil work, there are two main things that you should consider: texture and weight.

SURFACE TEXTURE

The texture of paper is sometimes called the tooth of the paper and for hyper-realistic coloured pencil work, you want to achieve a nice, smooth finish so you can really see the details that make all the difference. For this, a smooth, or fine tooth, hot-pressed paper is preferable. Hot-pressed paper has little to no texture, but still has enough for the pigment of coloured pencils to grip onto. In comparison, a cold-pressed (or NOT) paper, has many varying degrees of texture and this can be difficult to layer coloured pencil over to achieve a smooth aesthetic.

WEIGHT

The paper I prefer is Fabriano Artistico hot-pressed paper, which is actually a watercolour paper, but watercolour papers are perfect for coloured pencil work! This paper comes in different weights and the weight of a paper can really affect how many layers of pencil you can put down. Generally, the heavier the weight of the paper, the more layers you can add. Standard printer paper is a low weight (usually around 80–100gsm) and if you've tried working on it with coloured pencils, you will have found that you can put hardly any layers down on it. Change the weight of that paper to 300gsm (the weight I prefer) and you can add so many more layers and achieve much more realistic results. There are also 640gsm papers available (Fabriano

comes in this weight, too) and a lot of artists like to work on this heavier weight paper to enable them to add a lot of layers into their work. I find that 300gsm does the trick though. Although a heavier weight paper can take a lot of layers, it takes an exceptionally long time to create deep, dark colours and sometimes the paper can 'soak up' the colours, which means putting more pigment down.

Paper preference is a very personal thing and there are so many to choose from. Take the key points I've mentioned here and try different papers in a variety of weights and textures to see which ones you like, and which perform the best based on how you apply your pencils.

Erasers and Sharpeners

The other essential tools for coloured pencil work are, of course, erasers and pencil sharpeners. These might seem self-explanatory, but there are things I think you should consider when deciding what to buy.

ERASERS

I use two types of eraser when working on drawings: a kneaded eraser and a plastic eraser. Erasers are essential for removing graphite outlines and can also be used to remove some coloured pencil. It's difficult to completely remove coloured pencil, especially if a pigment is particularly staining (like reds and purples), but erasers can be used gently to create great effects.

A kneaded eraser is useful for picking up graphite outlines so that they're barely visible, which is just what you need for coloured pencil work. You can tack the eraser down onto your surface and it picks up graphite leaving a very thin trace behind. You can also use kneaded erasers to pick up coloured pencil and create highlight effects.

A kneaded eraser is mouldable, so if you have something of a particular shape you'd like to lift out, you can form that shape with the eraser and lift it out easily.

Plastic erasers are a little more commonplace, plastic is what most erasers are made from. They are great for general erasing and for completely removing a graphite outline. You can also use them to remove coloured pencil if you work lightly in layers. I have a Tombow Mono eraser, which comes in two shapes – round and rectangular. These are small, pen-like erasers, which are great for removing small details in coloured pencil work.

SHARPENERS

There two main types of sharpeners I'd like to mention: mechanical and handheld.

Mechanical sharpeners have a crank handle and sit on your desk. In my opinion, these are the best for coloured pencils. Mechanical sharpeners come in many different styles and brands, but they all sharpen to extreme points, which is crucial for detailed work. I prefer mechanical sharpeners because they last a lot longer than handheld ones and the blades stay sharper for longer, too. They also put no pressure through the pencil when sharpening, unlike handheld ones.

Handheld sharpeners can also get some great points on coloured pencils and come in a variety of different styles. There are specific handheld sharpeners made just for getting sharp points and there are those 'school-style' basic sharpeners, too. These are a great, cheaper alternative to mechanical sharpeners, but as I mentioned, they can exert pressure onto the pencil when sharpening because you're having to turn the pencil yourself, which can lead to core breakage or even wood casing damage. However, as long as your sharpener produces long, sharp points, then that's all that matters in terms of putting colour onto paper.

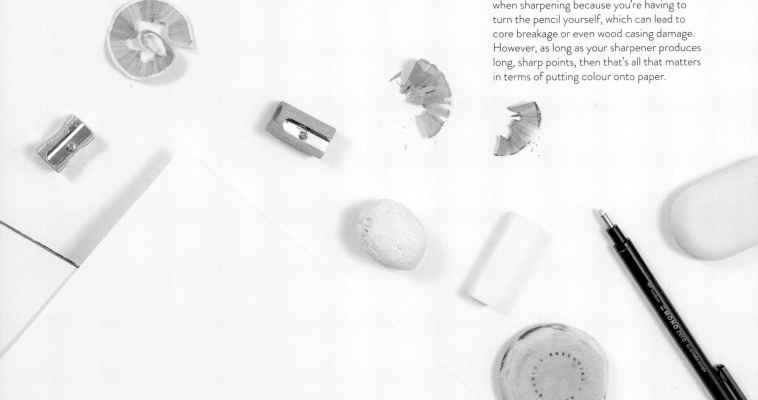

Composition

Composition is the arrangement of objects, or subjects, in a picture. Working out the composition is always important when starting a new piece as it can change the whole tone of an image.

PLAN COMPOSITION

How you plan a composition depends on what you're drawing. I find that the best compositions are those that, in the case of living creatures, capture the personality or, in the case of plants or vegetables, look the most natural. Planning the composition of manmade objects is more difficult so more thought is required to make a scene feel comfortable.

For any subject, think about what it is that you want to capture and how you can make it 'zing' on the paper. Creating composition thumbnails is a quick way to test out what works, and they can save a lot of time, ensuring you won't realize halfway through a piece that the composition isn't working.

Think about how the piece should be positioned on the paper, the lighting and, in the case of living subjects, where their gaze is focused. Obviously, you can place your subject in the centre of the paper, but this often looks boring. Placing the subject slightly off to the side creates a more dynamic composition, which includes both the subject and some negative space. This makes the viewer think about the intentions behind the placement. Maybe your subject is a cat that is looking off to the left, so you've positioned it to the right of the page. What's caught the cat's attention? What can it see? These are the sort of questions you should be thinking about when planning your work.

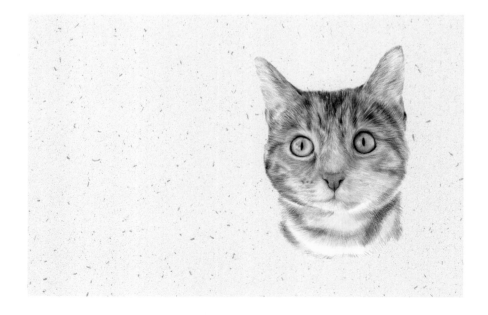

Reference Material

Nowadays, there are so many ways to obtain reference material and draw. Here, we'll look at those different options and their advantages and disadvantages.

DRAW FROM LIFE

The most obvious way to find reference material is to draw directly from life – it's the best way to observe three dimensions and it's also copyright free. Some things, such as plants, flowers, vegetables or everyday objects like mugs and vases, are easier to capture directly from life. As they remain static, it's straightforward to sit in front of them and observe them. However, if you want to draw things that move and change like animals or landscapes, then it's better to take photos.

Drawing a bell pepper from life

TAKE PHOTOS

Animals are hard to draw from life as they move about and won't sit for a drawing. This is where reference photos come into their own. With a reference image, you can capture exactly what you want for your piece, or capture multiple images and then draw from them.

However, there is a downside to drawing from a photograph: the image is flattened into a two-dimensional version, and it can be hard to identify proper form, tone and shadows from one image. It's best to take multiple images from different angles and perspectives so that you can refer back to them later. Doing this will help you to understand anatomy, lighting and any other visual effects.

When taking your own reference images, use the highest quality setting possible, use natural lighting, and take as many photos as possible. Taking multiple images enables you to combine them to form a solid overall picture of the subject.

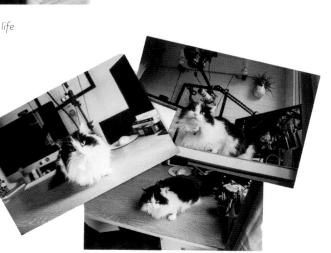

Reference images of my cat that I took myself

USE IMAGE LIBRARIES

Another way to obtain reference material is via royalty-free image library websites like Pixabay or Unsplash. These offer fantastic photos of absolutely anything and are great if you want to draw something that isn't easily accessible. There are also a lot of photographers on social media who will allow you to use their photographs for free or in exchange for a print of the finished work, or who will give you a discount to buy it.

When obtaining reference material online, make sure that you check the permissions for the image. Royalty-free sites have license usage pages that tell you what you can and can't do with the images. If you find images on social media, check who the original owner is and ask permission first. This will prevent any problems with copyright.

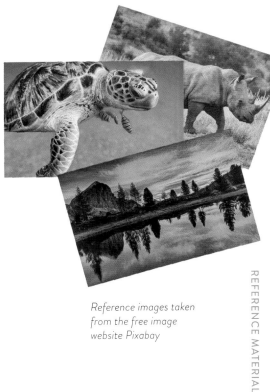

Reference images taken from the free image website Pixabay

Colour Theory

Colour theory is all about the relationships of colours with one another. The order in which you layer colours onto a drawing and which colours you place next to one another can really affect your results.

Colour theory is a big subject, so I won't go into too much detail. I'll explain the basics and discuss how to apply colour theory to drawing with coloured pencils to create realistic, non-muddy looking shadows without using myriad browns and greys.

If you're not familiar with colour theory, I highly recommend that you get a colour wheel as it will help with finding effective colour combinations, which in turn will help with creating shadows and vibrant tones.

COMPLEMENTARY COLOURS

Complementary colours sit opposite each other on the colour wheel. When they are placed next to one another, they help brighten and enhance each other. This is demonstrated in the examples shown. You can see that yellow is much more vivid when placed directly next to violet – a perfect match if you have a yellow flower that you really want maximum impact for.

When layered on top of one another, complementary colours create a neutral grey or dark tone, which is perfect for forming natural-looking shadows. Shadows formed in this way look less muddy and often have more depth and appeal than those created with a ready-made brown or grey, which can look a little flat and lifeless. You can see complementary colour shadows in action with the Bell Pepper project in this book.

You can create shadows of varying intensity using complementary colours with coloured pencils. Use a light layer of red over green to, ever so slightly, lower the brightness of the green, giving a very subtle grey tint. Or, you can add a few heavier layers over green to create a fantastic dark tone.

These rules don't only apply to the bright, pure colours, but can also apply to shades of colours (pure colours or hues mixed with black), like oranges and browns, blues and dark indigos. In fact, when mixing a Walnut Brown and Dark Indigo, you create a stunning dark tone that holds real depth.

COLOUR TEMPERATURE AND COLOUR SCHEMES

Colours can be grouped into warm and cool hues. If you split a colour wheel in half (between yellow and green and purple and red) you can see direct differences between the two colour halves. However, all colours can have a warm or cool temperature, which depends on what the original hue is mixed with. Red can be mixed with orange to create a warm red, or it could be mixed with purple to create a cooler hue. It can be difficult to determine a colour's warmth based on just looking at your coloured pencils, so try drawing out swatches of your colours so you can see what the colours look like on paper and the differences between them.

Why is this important? Well, warm colours tend to advance and cooler ones tend to recede. This is vital knowledge when you're trying to capture the form and structure of something. It can also be important when you're trying to create a cohesive colour scheme for your drawing.

When working with coloured pencils it tends not to matter too much about warm or cool colours as you can layer a lot of tones together, but putting warm tones on warm tones and vice versa does tend to make for a much more appealing build of colour and avoids areas looking too muddy.

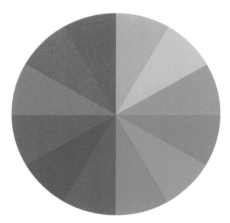

Colour wheel

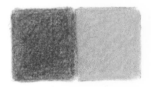

Some examples of complementary colours

Values and Tone

Value and tone play an important part in coloured pencil drawing. Having a black and white reference photo alongside your coloured reference (where possible) is a fantastic idea as it means you can see the image's values and tone directly.

Value refers to the lightness or darkness of a colour. You can see in the colour and black and white references below how colours, although different in hue, can be similar in value. Tone refers to a colour that is mixed with grey (or black and white) to dilute, or desaturate, it. You can add a lot of grey, black or white to completely desaturate a colour, or a little to dull it slightly.

WHY ARE VALUE AND TONE IMPORTANT?

The more you can identify these and apply them to your work, especially values, the more realistic your piece will look. There are great examples of different values and tone and how they can impact a drawing in the Full Studies section of this book. See the Spoon and the Ice in a Glass of Water projects for examples of lights and darks directly next to one another. These subjects have easily identifiable values as they're greyscale in appearance; however, when working in colour it can be difficult to identify the different values, especially if you have similar tones (such as red and orange) surrounding one another.

IDENTIFYING VALUES

An easy way to identify these different values is to squint your eyes at your reference material. This creates a blur that eliminates any outside distractions and allows you to focus on the colours you are seeing. Another way to identify value is to create a value strip and use it to identify lights and darks by holding it up to reference material and then selecting the relevant colour. You can see in the example below how the value strip relates to the greyscale drawing of the apple.

Tones are also important, especially as you gain more experience, because you can use tone to focus on a particular colour or element in a drawing by adding grey, black or white and desaturating areas around your focal point.

An example of a value strip

Black and white images allow you to see tonal values more clearly

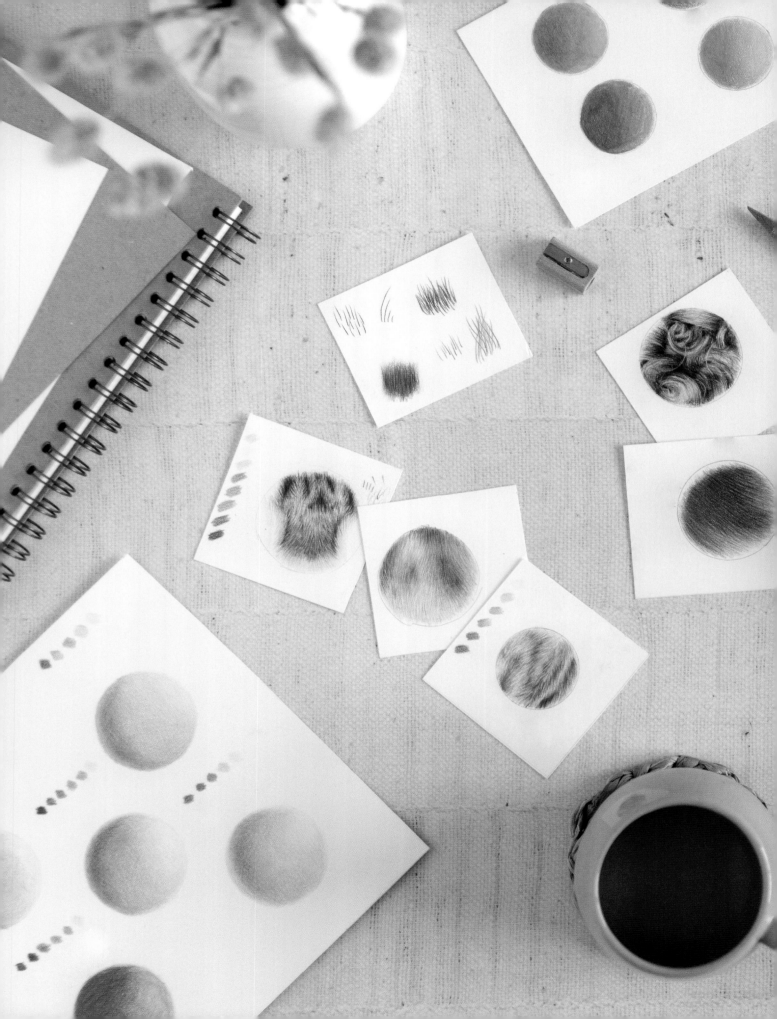

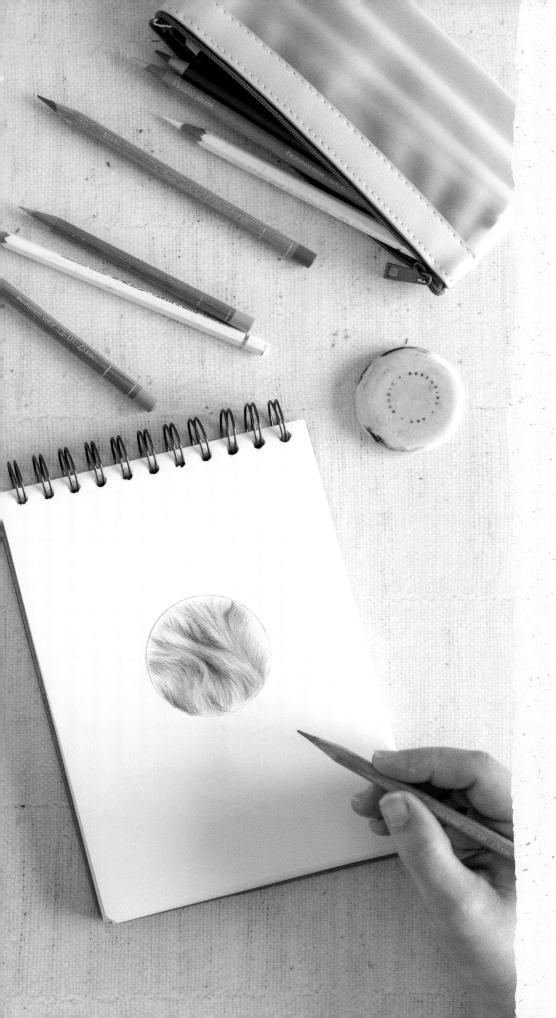

Shading and Glazing

The way you hold your pencil has a huge influence on the type of shading created and the marks made on the paper. In this section, I'll walk you through this and explain the most common ways to hold your pencil and the marks the different holds produce.

Shading is the fundamental method used for adding colour. It is what we use for adding base layers – which tend to be the lightest tones in a coloured pencil piece – but you can also use shading in the later stages of a piece to slightly alter the tones of colours; I refer to this as glazing, but it is the same technique, whatever point in a piece you use it.

LIGHT SHADING

To produce light shading, hold your pencil almost horizontal to the paper and as far back on the barrel as is comfortable. Holding the pencil in this way really limits the amount of pressure through the tip and allows you to create soft washes of colour. This is the perfect way to build tone slowly.

When shading like this, it's important to keep any tension out of your hand and let the weight of the pencil on the paper do the work for you. Keep a nice, loose wrist and try to keep the shading smooth – back and forth – across the surface.

MEDIUM SHADING

Moving your hand up the barrel of the pencil towards the tip will help you to apply a little more pressure to your pencil, which means you can lay down a slightly heavier tone of colour a little more quickly. This also means the angle of your pencil changes. The angle for this level of shading tends to be about 45 degrees to the paper. This is effective for darker-toned objects, where a lighter colour isn't necessary for a base. Maybe you've got something opaque like a dark leaf or a pot to draw. This would be a great way to hold your pencil for that initial shading. I find this method effective for putting colour down quickly, but it is also more likely to produce uneven colour.

HEAVY SHADING

Holding your pencil towards the tip and positioning it almost upright results in heavy, block-type shading. This pencil position is mostly used for adding in details because you can put quite a bit of pressure through the tip of the pencil and maintain a lot more control over where the pencil strokes are. While this method is commonly used for adding details, you can also add shading in this way, and it is especially effective if you have big, dark areas to add in. When using this method, I apply a lot of tension through my hand to achieve a heavy pressure, but you can also use this pencil hold with a lighter pressure, too. I also find it easier to shorten my pencil strokes in this position.

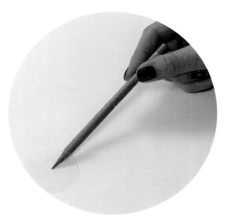
Light shading

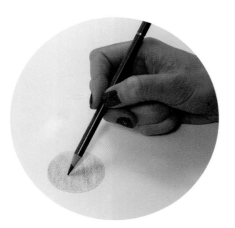
Medium shading

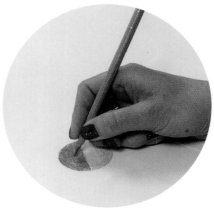
Heavy shading

SCUMBLING

If you want to achieve a smooth, slick surface texture, you can do that by drawing small circles and overlapping them to fill an area. I tend to use the medium shading pencil position for this – holding the pencil loosely and at a 45-degree angle to the paper – pretty much a normal position for holding any kind of mark-making implement. Instead of moving the pencil back and forth, make small, open circles and pack them closely together to fill the area. This method of shading allows you to fill the tooth of the paper and is great for smooth subjects like eyes, skin, glass etc.

GLAZING

Finally, there is glazing. This technique overlaps with layering (see Layering) but it is worth mentioning here because the method of application is the same as for light shading. Hold the pencil as you would for light shading to limit the amount of pressure going through the tip. This will allow you to apply a light, pale layer of colour over an existing one. This method is often used in the final stages of a drawing when subtle differences are needed for shadows and to convey dimension.

TIP

Light and medium shading are best for base layers. Heavy shading is best for top layers and for adding details.

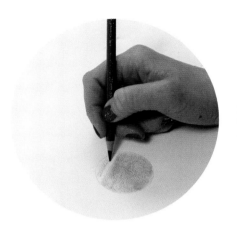

A light red glaze is applied to the second yellow circle to change the warmth of the colour very subtly

Practice Exercise

Try using different hand positions and pressures to make some marks on paper and see what difference they make to the tone of the colour you're applying. Different colours produce different results, so try using a variety of pencils to get to grips with how you can vary your shading. The full body Dog project was completed by adding many layers of light, medium and heavy shading.with no fine-detail hair strokes.

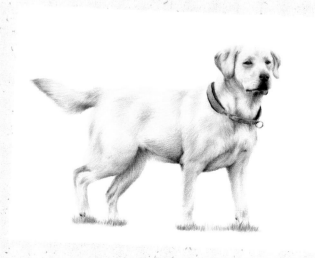

Layering

Layering is a fundamental technique for drawing with coloured pencils as it's what builds tone, colour and everything that will make your drawing realistic.

In coloured pencil drawings, we usually work from light to dark, as it's easier to add dark colours over light but not light over dark. Light coloured pencils tend to be quite transparent and hard to layer over darker hues. Layering of colours is also affected by the type of paper you're using. Lighter colours perform better over dark colours on a more sanded paper, like Pastelmat. Your paper will determine how you work so if you prefer a more sanded paper, you will be able to work a few lighter layers over dark colours.

Generally, however, light colours go down first to create base tones and these initial tones form the highlights of a coloured pencil piece. You can also put down light-shaded darker tones at this stage to identify any prominent shadows. After the highlights come mid tones, which add depth to colours. The final layers will be the darkest and heaviest colours. These layers often include shadow tones, too, which may not always be the darkest tones but complementary colours of your mid and base tones.

LAYERING SEQUENCE

Layering methods vary depending on the stage of the drawing and the subject but, generally, layers are added using light pressure to gently build colours up. Firmer pressure is used more towards the end to blend and burnish.

A back-and-forth shading technique is usually used for base layers. If you're working on something with texture, make sure your shading follows the texture pattern and direction if there is one. Base tones usually comprise several light layers – I recommend adding at least four layers of colour to help fill the tooth of the paper.

Mid tones can be added in with shading; again, follow the direction of texture on the object you're drawing. You can also add in layers of detail and start to build in any texture at this stage. Whether you do add details at this stage depends on the texture you're building.

The final layer consists mainly of filling in details, building shadows and adding depth. The marks you make may be mainly for creating details but can also include a shading method when building shadows.

Light tone

Mid tone

Dark tone

LIMIT YOUR PALETTE

When layering, take care not to add too many different colours, as this can muddy the look of a drawing. Therefore, paying attention to colour theory is wise, because it can help eliminate any problems you encounter when layering.

If you're building a red-coloured object, your base tones will be light reds and pinks, the mid tones will be deeper, scarlet-hued reds and then finally your top layers will be dark reds and possibly greens to add into shadows.

Now, if you were to add purples and blues to try and create contrast, or add in too many varying shades of green, you would end up dulling and muddying the red colour, especially if all those colours were also a mixture of warm and cool tones.

So, it's important to select similar colours or tints for your base tones, pure colours for your mid tones and then shades for your dark tones, keeping within the same colour family and adding hints of other colours sparingly.

Building the base with the lightest tone of pink

Adding in the slightly deeper reds for the mid tones

Adding the darkest red tones and green for the shadows

Practice Exercise

Practise layering your pencils with different pressures to see how easily you can build tone, and also layer complementary colours on top of one another to see how colours change and interact with one another. The Bell Pepper project uses lots of layers of red, it also uses green layered over red to create realistic shadows.

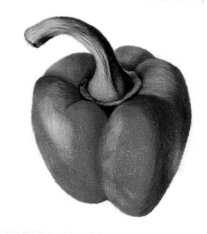

Blending

Blending means to merge colours together seamlessly. Blending can be used to produce an ombre effect, to create a seamless transition between colours, to eliminate the grain of the paper, and to smooth the look of coloured pencils. There are two main types of blending for coloured pencil work: wet and dry.

WET BLENDING

Wet blending is the name for using solvents to dissolve pigment binder and gently move colour around on the paper. Solvents, or odourless mineral spirits, are used primarily as a tool for painting but can help give a coloured pencil piece a painterly effect. Blending in this way produces incredibly smooth results and will allow you to increase the number of layers you can add to a piece, especially when using wax-based pencils.

The blending medium is applied to coloured pencil layers using a paintbrush, or anything that will hold a little of the liquid and is soft enough to gently brush across the surface of the drawing. The key is to make sure the implement you're using is neither too wet nor too dry. To do this, dip your paintbrush, or whatever you're using, into the liquid and wipe off any excess on the side of the container, then gently dab any remaining excess off using a piece of paper towel or a cloth. This will give you the perfect amount to blend with. This is an important step because if you have too much liquid, you'll create blotches in your work where the pigment has been moved too far. Too little liquid and your piece will not blend. Alternatively, you could use a blender pen, which will control the amount of liquid added to your piece.

Always work from light to dark when wet blending, otherwise you risk pulling the darker pigments into light areas and losing any defined highlights. Use small circles if you're blending smooth surfaces, while a back-and-forth motion is best for textures like fur or fabric.

When working with blending mediums, you'll find that it becomes easier to put more pencil layers down. This is because the solvent breaks down the pencil binder and this is left on the paper. You'll also find that you can more easily add white pencil over darker areas, which is fantastic for adding in delicate highlights that are hard to capture using an embossing tool.

Wet blending with no layers added

Wet blending with layers added

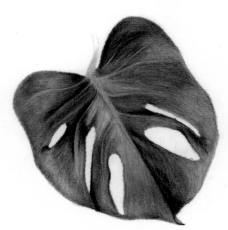

Wet blending in use

DRY BLENDING

Dry blending occurs naturally in coloured pencil drawing as you add more layers to your image. It comes even more naturally when working with wax-based coloured pencils. The more layers you add, the more you're working and incorporating those layers into your work. This type of natural blending comes from increased pressure on pencils when adding in details and deepening shadows. Natural blending helps to smooth out the grain of the paper. But what if you only have a few layers or want to seamlessly transition colours? Dry blending is all about increasing the pressure you use with your pencils to create that blended, smooth look.

You can dry blend with any of your coloured pencil tones, but I prefer to blend with a transparent white pencil or using the lightest tones from whatever colour scheme I am using for a particular piece. Layers are usually applied in a light, gentle manner to build the saturation of a colour, but with blending, you increase the pressure to flatten out the tooth of the paper sooner to achieve fast, smooth results. A lot of people favour this method because it works naturally for them, but others dislike the dry blending method as it causes extra exertion on the wrist and can become uncomfortable, especially if you're having to blend a lot.

Dry blending with white

Dry blending without white

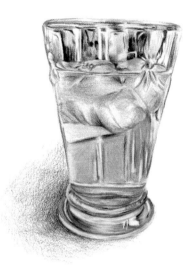
Dry blending in use

Practice Exercise

Build up two circles of colour, one side lighter than the other and practise blending using your preferred method – or try both methods to see which one gives you the best results. You can also try the same process but fill your two circles with two different hues to blend seamlessly together.

Wet blending

Dry blending

Shiny Surfaces

Drawing shiny surfaces is the perfect way to get to know your coloured pencils and get to grips with different techniques. Shiny surfaces tend to be smooth and somewhat reflective.

Drawing realistic surfaces may seem daunting because of the reflections but creating a realistic, smooth surface really only entails concentrating on a couple of key techniques.

Small circles

Cross hatching

FILLING THE TOOTH OF THE PAPER

The first key technique for drawing a smooth surface involves making sure the tooth, or texture, of the paper you're using is completely filled. The easiest way to do this is by making small circular motions with your pencils instead of using a back-and-forth shading motion. This will create a smooth look and allows you to apply the same pressure throughout the drawing. You could also use a cross-hatching method – shading one way and then in the opposite direction on the following layer – but small, gentle circles work just as well, if not better.

MAP OUT THE HIGHLIGHTS

The second key technique is mapping out any highlights or reflections and keeping them paper-white for as long as possible to build up the shadows and tones around them. The key to hyper realistic looking surfaces is keeping the contrast high and having lots of light and dark areas.

SURFACE TYPES

Of course, not all surfaces are smooth or reflective; however, you can still use the initial technique of creating small circles to build base layers and then build texture on top of that, and again, you can create this texture by mapping out light and dark areas.

Reflections and metallic-looking objects can be incredibly difficult to render, but if you pay attention to the highlights and shadows and the intensity of both, the surfaces become easier to recreate.

Glazed pot

Gold metal

Shiny black pot

Feathers and Birds

Feathers and birds are, in my opinion, one of the most fun things to draw, although feathers can be a little tricky to get right. Depending on the type of bird, feathers can throw up all types of complications but some can be incredibly easy to structure.

FLUFFY FEATHERS

The easiest types of feathers to draw are the fluffy, downy ones that closely resemble fur. Draw these by putting in base layers that follow the feather direction and then, using darker pencils, add lines like fur lines to give a soft, fluffy texture. This type of feather appears in the Parrot project, along with a few other types.

LONG, SLEEK FEATHERS

It's best to render long, sleek feathers using lots of layers and blending – either wet or dry – to create as smooth an appearance as possible. When drawing an individual feather, it's easy to create form and realism. It's when these types of feathers are grouped together, usually in the form of a wing, that they become tricky. Because shading plays an important part in how the feathers look, the main thing is to define the edges of each feather and add shading beneath the feathers that sit on top of others. There is an example of this in the illustration below, where I've left out all other shading and just presented where you would shade.

SCALLOPED FEATHERS

The same technique applies to scalloped feathers, which you might find on a hummingbird or something similar. The idea would be to map out all the individual feathers and how they interact with one another, and then fill in the shadows and highlights. The feathers found on hummingbirds are often iridescent, so careful thought is also required for any necessary highlights or colour changes. You can also get fluffy scalloped feathers, which you will see on the Parrot project. These are rendered in the same way as scalloped feathers.

BIRD FEATURES

The beak is one of the easier features to render and can be successfully captured by using wet blending. This technique can also be used for the eyes. They are often dark and beady and only require the slightest highlight to make them sparkle.

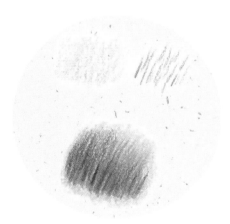
Fluffy feathers

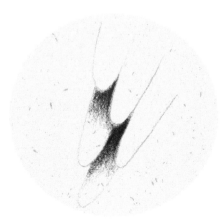
Long, sleek feathers

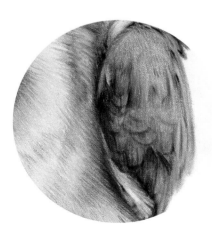
Scalloped feathers

Fur and Animals

In this section, you'll be shown how to add fur lines to an image. We'll start with the concept of the tapered line – followed by how to add the tapered line over existing colour to create details. We'll also look at some different fur textures and how you can approach them, before looking at other animal features.

Fur comes in a huge variety of colours and textures so there's not a 'one-size-fits-all' technique. Drawing long, wavy fur requires a very different approach to drawing short, wiry fur. The same fundamentals are all there – the approach to shading, layering, and generally working in a light-to-dark sequence – but the application of the final layers, adding in shadows and working out how to convey the different textures is crucial.

THE TAPERED LINE

The first step is to master the tapered line; this is what forms the fur texture over the top of shading and layering. Start with a sharp point on your pencil with the tip against your surface. Move the pencil in the direction the fur is going and as you're moving along the line, gradually lift the pressure from the pencil. The idea is to make a rapid movement and create a line almost like the end part of a 'tick' so that you have a nice, soft end to the line created.

It can be tricky to master this so don't worry if you don't get it right on the first stroke. Keep practising, starting slowly at first and then aim to become quicker. Once you've got this technique down, you can start to group the lines together to form a deeper concentration of colour. When grouping together, aim to

have a little natural bend and variation between the lines. Having the lines overlap towards the ends is fine, just try not to bend the lines too much and exaggerate the fur stroke. I find this approach looks the most natural and the least static.

The longer the fur, the longer you'll want your fur lines to be (and vice versa for short fur). Longer fur requires more shading than shorter fur lines and you'll find that it's the shorter fur that really requires you to focus on putting a lot of fur lines down.

When it comes to adding fur lines to a piece to create texture, the point to start adding them is in the mid tone section – the first few layers of shading should create a good base for the fur lines. When you first add fur details, group your lines closely together to establish that colour and, as you move onto darker tones, keep your fur lines fewer and further apart. Your darkest colour should consist of the fewest fur lines, and they should be placed quite far apart. This rule applies to all colours, even black fur, as you want to be able to see all the mid tones shining through to create the fur's depth.

The tapered line

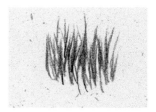

Grouping tapered lines

Naturally placed tapered lines

Overlapping tapered lines

FUR TYPES

TABBY FUR

Tabby fur requires a lot of short fur strokes. It also requires a lot of the lighter base tones to be visible, so when you're adding your mid tones and building texture, you'll want to start with those lines spaced quite far apart so that the lighter tone underneath is visible. This creates a flecked appearance where the fur strands may have a darker tip and lighter base. The darker areas of tabby fur follow the same rules as above, but with the lines grouped closely together to create a darker concentration of colour. Tabby fur is a good example of how the spacing of fur lines can create different effects.

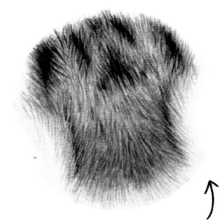

Tabby fur flecked with lots of darker lines

WAVY FUR

Wavy fur calls for a different approach because the majority of the texture is created by shading. When drawing wavy fur, start by working from light to dark, shading the base layers and defining shadows. There are a lot of different fur directions to consider, and it can be quite time-consuming to map everything out and making sure the fur 'flows' correctly. The easiest way to tackle this is to put a good base down, define the shadows with your darker colours and then go back and add in the mid tones to blend the two areas together. It's also useful to think of the fur in terms of clumps; the clumps each being a section of fur that moves in a certain direction. You may have one clump of fur that sweeps to the left, another to the right and then another that sweeps off to the left again, making three individual clumps. Between these clumps is where you would need a lot of shading – and towards the middle you'd find your lightest tones.

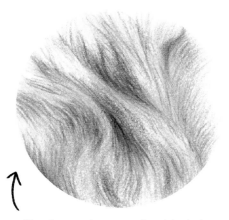

Wavy fur contains many soft, subtle shadows

CURLY FUR

The same approach is used for curly fur – although this type of fur can be a little more involved and requires forethought about any overlapping light areas of fur. When drawing curly fur, before adding in any layers, I like to use a white pencil to define where there is some white overlapping, curly fur. Alternatively, you could use an embossing tool to indent white lines on the paper or a craft knife to etch away the layers of coloured pencil once added. We'll look at using an embossing tool in the Cat's Ear project.

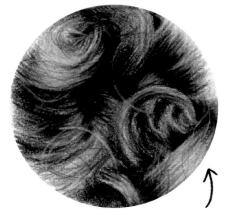

Dark shadows highlight the curls in this fur

People

Drawing people can be quite intimidating, especially if you're drawing someone you know. There are many different things that need to be taken into consideration.

The main things to get right when drawing people are proportions, anatomy and convincing skin tone.

SKIN

Skin makes up the majority of a human portrait and creating the right tones can be tricky because there are so many different colours and tones to create. The main undertone for drawing skin tends to be Ivory. This is an extremely important colour for highlights when working with any shade.

CREATING SKIN TONES

On the page opposite, five basic skin tones and the colours needed to create them are set out. The colours are listed in the order they've been put down on the paper.

Skin is rendered using layers, laid down gently at first, using either a small circular pencil motion, or using a cross-hatching shading method. Once the initial layers are down, pressure is gradually increased to create a smooth look. The lighter colours are used to blend the skin tone as white can desaturate the colours and more

effort is then required to build up the correct tone.

One of the main difficulties of rendering skin is over-working and making the shadows look muddy. Avoid this by layering in similar colours and by avoiding too many brown layers or too many brown colours. Of course, some browns are necessary to create a darker tone but it's always a good idea to stay with one brown shade, which is similar in warmth and shade to the colours already used.

HAIR

Hair is drawn in the same way as fur is drawn for animals, with the length of the hair determining how long your pencil strokes are. The longer the hair, the longer the stroke will be and even shading will be required to render long, wavy locks. Short hair requires shorter pencil strokes. The pencil stroke is the same as you would use for fur, where you create a tapered line by lifting the pencil from the paper as you work along the strand.

Hair is also about creating 'clumps' and defining the shadows. Shadows make up the form of the hair and I always put these in first, along with a base layer and then go back into the shadows with mid tones and build back up to the darkest tone.

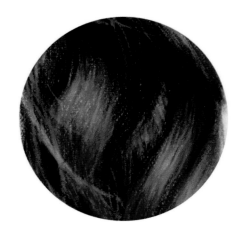

Light

Fair

Mid brown

Ivory (103)

Beige Red (132)

Cinnamon (189)

Coral (131)

Walnut Brown (177)

Ivory (103)

Beige Red (132)

Burnt Ochre (187)

Sanguine (188)

Permanent Green Olive (167)

Ivory (103)

Burnt Ochre (187)

Bistre (179)

Van Dyck Brown (176)

Skyblue (146)

Medium

Dark brown

Ivory (103)

Cinnamon (189)

Coral (131)

Burnt Ochre (187)

Sanguine (188)

Burnt Sienna (283)

Ivory (103)

Coral (131)

Burnt Ochre (187)

Burnt Sienna (283)

Walnut Brown (177)

Manganese Violet (160)

Quick Studies

TECHNIQUES USED

- Shading
- Layering
- Blending

Leaf

—

Leaves are often smooth, sometimes shiny structures and the best and easiest way to render a smooth surface is to use a blending medium like a solvent or blender pen. These make the work a lot quicker and give really polished results.

YOU WILL NEED

Pencils

 Cream (102)

 Chromium Green Opaque (174)

 Chrome Oxide Green (278)

 Green Gold (268)

 Permanent Green Olive (167)

 Earth Green (172)

 Permanent Green (266)

White

Other tools and materials

Solvent or blender pen

TIP

Permanent Green Olive makes the perfect 'leafy green' when used lightly and blended with Earth Green.

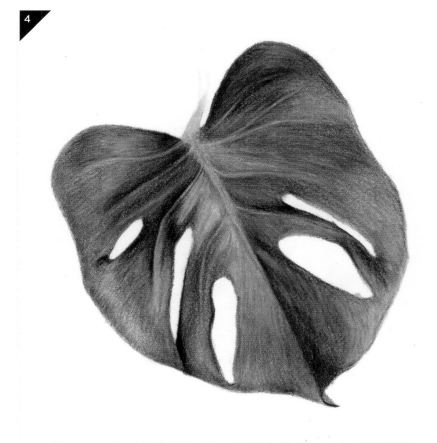

1 Start by adding the leaf's shadows. These occur where there are folds or bends in the surface. Use Chromium Green Opaque with light pressure to shade back and forth into those shadows. If you need to go a little darker in some places, add a light layer of Chrome Oxide Green. Gently lift the pressure from the pencil as you move from the shadows and blend into the lighter areas. Where there are more harsh shadows, just blend a little into the lighter areas. Once the shadows are in place, add a layer of Cream over the entire leaf.

2 Add the mid tones using Green Gold, Permanent Green Olive and Permanent Green. Work into the lighter areas with light pressure and blend into the shadows. Pay attention to areas where the leaf looks a little more yellow and add Green Gold into those places. Make sure that all your tones are smoothly blended and if they're not, add light layers of shading to help. The only exception to the smooth blending is at the core of the leaf, make sure that this has defined edges.

3 Using solvent, or a blender pen, work from the lightest areas of the leaf into the dark, gently blending the pigments together and creating a vibrant look. Use a circular motion with your brush or pen to help create a smoother surface on the leaf. You may find that the leaf looks patchy, but that's okay as we're going to add a final layer over the top to create that smooth, waxy surface.

4 Now it's time to refine the piece and add a few final layers to smooth out any unevenness and any paper grain showing through. Using the same motion and technique, shade down the variety of greens, really focusing on creating definition between the light and dark patches. For the shiny highlighted areas, add some more Earth Green but follow it with a generous layer of white and blend into the surrounding areas. You can also use white to highlight the veins; shade on one side to suggest that they are protruding a little. Make sure to add the shading on the same side of all the veins. Use a sharp pencil to make sure all the edges are nice and crisp.

TECHNIQUES USED
- Shading
- Layering

Bark

—

Bark can look quite complex, but if you follow the basic principles discussed in the first section of the book – adding in dark areas first and building from there – drawing it is actually a fairly simple process. The layering of the mid-tone values here is crucial.

YOU WILL NEED
Pencils

Warm Grey 3 (272)

Warm Grey 1 (270)

Light Cadmium Yellow (105)

Light Green (171)

Green Gold (268)

Dark Sepia (175)

Pine Green (267)

Van Dyck Brown (176)

TIP

Use a small circular pencil motion to recreate the dappled, variegated texture of bark.

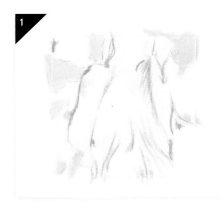

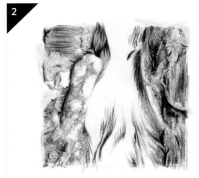

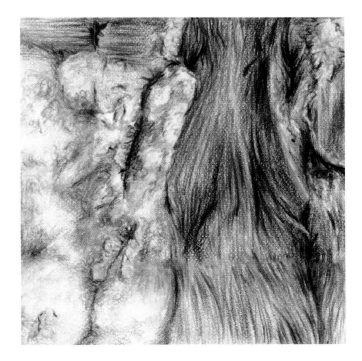

1 Start by defining all the darker, more prominent areas of bark with Warm Grey 3. The darker areas could be any naturally dark pieces or any grooves between the different bark plates. Start off with light pressure and then increase the pressure once you're happy with the placement of the colour. Next, shade in any lichen that is present. I've used a mixture of Light Cadmium Yellow and Light Green here to form a soft yellow green as a base. Map out the shapes using light pressure and then gradually build up pressure once the form is correct. Add a layer of Warm Grey 1 to form an all-over base, making sure to shade around any areas of lichen but over the darker areas of Warm Grey 3

2 Darken the shadows created in the previous step using Van Dyck Brown and add light shading around the lines drawn previously to smooth contours and add a gradual deepening of colour. Layer some Green Gold onto the patches of lichen, mainly focusing on the darker areas. Add small lines and patches of Pine Green to enhance shadows and create tiny creases in the surface of the lichen. Use Warm Grey 3 with a small circular motion to build the shadows around the lichen and the shadows previously defined – leave out only the lightest parts of the bark. The circular motion helps to build the mottled texture of the bark; focus this pencil motion on the outer areas where the bark is a little more textured. For the smoother sections, follow the direction of any visible lines and use a soft, back-and-forth motion to fill in darker sections.

3 Using Dark Sepia, deepen the shadows once again, taking care to use the circular motion to bring the shading outward to create a gradual transition. Use Van Dyck Brown in the same areas to add depth and structure. Use both colours to draw small lines to form any intricate grooves and notches within the bark. Combine this with some Pine Green to enhance the shadows a little more.

4 Drawing bark is all about recreating its rough texture and sharp, harsh lines are needed to depict this accurately. Make sure to keep a nice, sharp pencil to keep those lines precise.

TECHNIQUES USED
- Shading
- Layering
- Blending

Grass

—

Grass is an easy texture to render. It has a similar structure to fur, the individual blades taper off in the same way that hairs do, which means that you can use your pencil in the same way when adding in small and larger blades of grass. Darker colours are used to indicate overlapping blades of grass where the green intensifies.

YOU WILL NEED
Pencils

Cream (102)

 Grass Green (166)

 Chrome Oxide Green (278)

 Permanent Green (266)

┌─────── TIP ───────┐

Remember to add a slight, natural blend to your blades of grass so they don't look static and unnatural.

└───────────────────┘

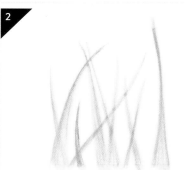

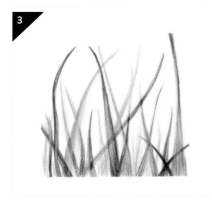

1 Using Cream, draw the visible blades of grass, taking care to follow the ways in which they bend and interact with one another.

2 Use Grass Green to gently shade along each blade to give a light yellow-green hue. Then gradually increase the pressure to add the shadows along each blade. Again, take note of how each blade interacts and overlaps with the others as this will dictate where some shadows fall.

3 For the final step, blend and incorporate the green tones in each grass blade using the Cream pencil and then, using Permanent Green, build up the green tones in selected areas where the grass overlaps. Increase the dark tones using Chrome Oxide Green and blend once again if necessary. Add in any additional light strands and add a little shading to indicate more grass in the foreground and background.

4 Grass is fairly easy to render, just remember to look for overlaps and add the relevant shadows.

TECHNIQUES USED
- Shading
- Layering
- Glazing

Rocks

—

To draw the texture of rock it's generally best to start with a smooth, shaded base of lighter colours and then move into the darker colours where texture and form are added. Rendering shadows is integral to creating a very porous or bumpy texture.

YOU WILL NEED
Pencils

Warm Grey 1 (270)

Warm Grey 3 (272)

Cold Grey 3 (232)

Cinnamon (189)

Payne's Grey (181)

Dark Sepia (175)

Bistre (179)

White

Other tools and materials

White gel pen

TIP

Use smooth shading and light pressure to build shadows and texture. Circular motions help with building a rougher texture.

1 Fill the entire rock area with a light base of Warm Grey 1. I recommend using small circles to create and build the tone; however, any type of shading will work, as long as it's smooth. Create some of the darker rock tones with Warm Grey 3, again using the small circular motion and increasing pressure where necessary. Use lighter pressure to taper out of the shadows and into the lighter surrounding areas. Add a little Cinnamon into the darker areas for some variation of colour.

2 Continue darkening the shadows using Cold Grey 3 and Warm Grey 3, alternating between the two to create a good mix of warm and cool tones. Use the circular pencil motion to build the mottled texture. Blend the texture a little using Warm Grey 1 and then continue to build darker tones by introducing Payne's Grey.

3 Continue to darken gradually, using the same techniques and colours but mixing in a little Cinnamon to give the texture a little more interest. Using Dark Sepia and Payne's Grey, add in any tiny details and shadows that you can see on the rock surface – again, do this using small circles. If a rock has a particularly porous texture, lots of this texture can be added across the surface.

4 To finish, add a glaze of Bistre and Cinnamon into the shadows and very lightly into the lightest areas. You can also use a white pencil or white gel pen to pick out any particularly highlighted areas across the rock surface.

TECHNIQUES USED
- Shading
- Layering
- Blending

Fabric

—

Fabrics have a lot of texture, and it can be tricky to get it all down on paper. I find that using an additional tool, like an opaque white gel pen, is ideal for adding in highlights within the weave of a fabric. It's also important not to add too much detail; just highlight one or two areas with the most detail.

YOU WILL NEED
Pencils

Skyblue (146)

Dark Indigo (157)

Indanthrene Blue (247)

Ultramarine (120)

Middle Phthalo Blue (152)

Dark Sepia (175)

Cadmium Orange (111)

Cold Grey 3 (232)

White

Other tools and materials

White gel pen

TIP

Having the texture of the paper showing through works brilliantly for fabric and helps add to the texture, so don't be afraid to leave paper showing in places.

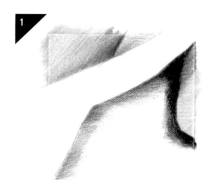

1 Start by defining the fold using Dark Indigo, use light pressure and gently map out how the fabric falls and forms. Once you're happy, go in with firmer pressure and add a little shading around these mapped out lines in the direction that the light is falling. Use soft pressure and gently build to create a deep shade at the edge of the fold that gets gradually lighter towards the lighter tones. Add in soft layers of Skyblue, Indanthrene Blue and Ultramarine to give depth to the shadows. In smaller patches of lighter denim, shade Skyblue following the grain of the fabric. The direction of the grain should be slightly different on each fold. Continue to add to the shadows and flesh out some of the smaller top sections of fabric.

2 Add the main fold of fabric by layering on Skyblue and slowly building and fading the shadows using the other hues of blue. Shade back and forth to add light layers that follow the direction of the fabric grain. Really blend the blues together to form different shades and areas of interest. I've used Cadmium Orange in the shadows (the complementary colour for blue) to create depth and a

natural looking grey. I've also used this colour in 'stripes' through the fabric to create texture and natural grey areas. You can also exaggerate the fabric weave by drawing small lines in the fabric direction using Dark Indigo with light pressure.

3 Fill in any remaining folds of fabric using the lightest colours first and then shading in the direction of the fabric grain. To add contour and desaturate the blues, add in a little Cold Grey 3 and Dark Sepia. Add Dark Sepia to the shadows and sparingly throughout the other parts of fabric. Next add a small amount of Cadmium Orange to provide a sharp little contrast, add greyscale and bring out the blue tones at the same time.

4 If there are any white parts that need picking out, use a white pencil to add these in. It can be tricky adding white fleck over the top but a sharp, white pencil, or a white gel pen, should do the trick.

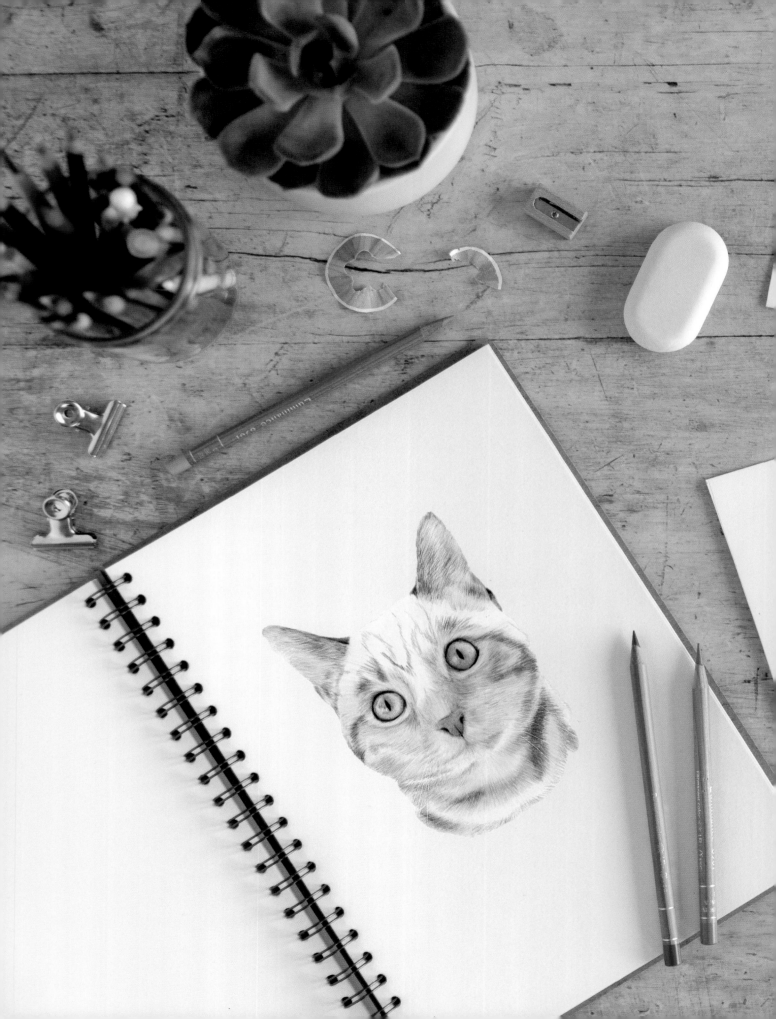

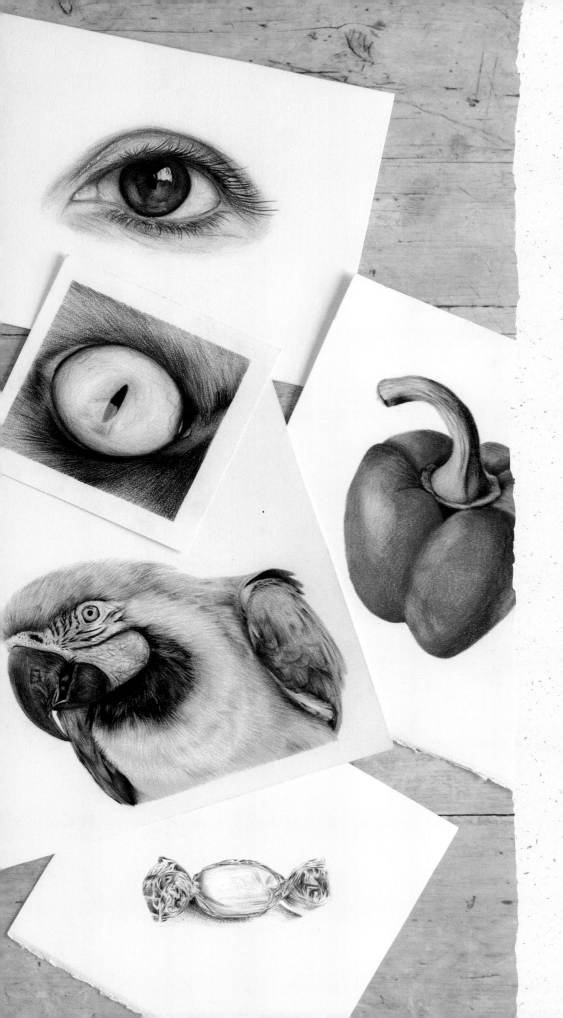

TECHNIQUES USED

- Shading
- Layering

Bell Pepper

—

This first full project is one that will get you used to layering, and also mixing, colours to create darker alternatives. The red and green colours of the pepper work well with one another to create a vibrant piece.

YOU WILL NEED

Pencils

- Warm Grey 1 (270)
- Skyblue (146)
- Pink Madder Lake (129)
- Grass Green (166)
- Pine Green (267)

- Deep Red (223)
- Deep Scarlet Red (219)
- Light Cadmium Red (117)
- Magenta (133)
- Permanent Green (266)

- White

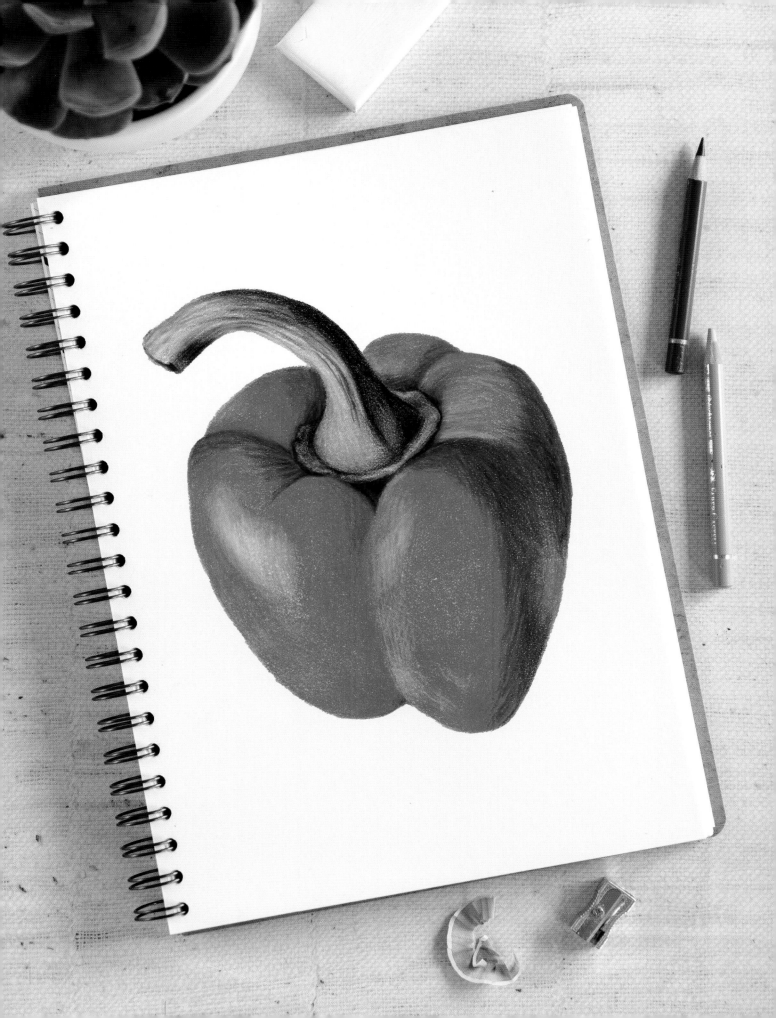

1 To start, layer in the highlights. Starting with the red highlights and using light pressure, layer on Warm Grey 1 and follow it with a light layer of Skyblue. Some highlights may be pinker toned so add in some Pink Madder Lake where you have warmer shadows. You should end up with a slightly purple tone to your warmer shadows. Use the same process, starting with Warm Grey 1, for the green stalk but this time follow with Grass Green.

2 Now define the pepper's shadows. Starting with the red areas, layer in some Deep Red, putting down a couple of layers to fill the tooth of the paper before adding Pine Green over the top. These two colours will combine to create the perfect dark, neutral colour. Use the green lightly over the red and then continue to layer the red back over to smooth the tone out. Concentrate more layers of green and red in the darkest areas around the base of the stalk. For the stalk, apply the same technique but use the green first, then layer in the red, followed by the green once again. You should be able to see a slight difference in the tones created – the green being cooler and the red being warmer.

3 Next, develop the mid tones and fill in the red surface of the pepper. Start by layering Deep Scarlet Red over the entire surface using light pressure and gently building up the tone. Use Light Cadmium Red to add in some of the warmer, brighter tones. These tend to be around any highlighted areas. Layer Magenta into the darker parts of the pepper, leading into the darker shadows defined in the previous step. You'll also want to add this colour around the base of the stalk and bottom of the pepper. If you need to smooth the texture out, add a light layer of Pink Madder Lake.

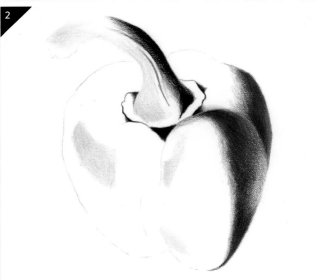

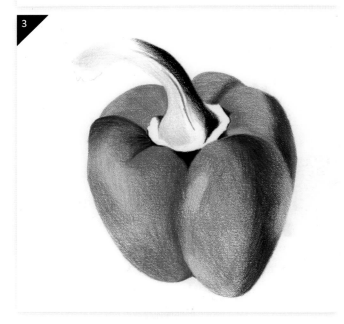

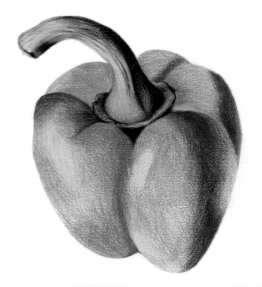

4 Fill in the remaining green areas of the stalk using Grass Green and then begin to flesh out darker patches using Permanent Green. Layer these two colours to cover the entire stalk. Keep the pressure light and use small circular motions to fill as much of the tooth of the paper as possible. Use Skyblue on the highlights of the stalk, going over the green layer to create a cooler green. Do the same towards the tip of the stalk where light is reflected. Use Pine Green to add in small details and shadows to the stalk, making sure to blend and shade using the lighter colours. Add some red into the darkest shadows, followed by green in order to keep the contrast up and keep the stalk looking three dimensional.

5 Start filling in and boldening the colours of the pepper using Deep Scarlet Red and Light Cadmium Red, depending on whether you can see a warm or cool tone. Increase the pressure to really flatten out the tooth of the paper and get bold, saturated colour down. Remember to go in with Deep Red and Pine Green to enhance any shadows as you work.

6 Continue as before until the entire pepper is covered and highly saturated. As a finishing touch, check on the contrast of the piece and alter the shadows if necessary. You can also use a white pencil to add in any highlights and add a sheen to the pepper. This will also help to smooth out the areas that don't contain a lot of layers.

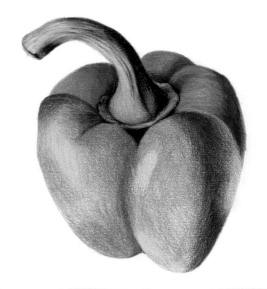

> **TIP**
>
> Use smooth, light layers and keep the surface looking as grain-free as possible by working in small circular motions or by shading in alternate directions.

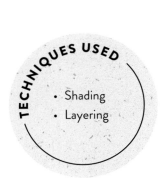

TECHNIQUES USED

- Shading
- Layering

Spoon

Drawing spoons is a great way to practise getting that smooth, metallic look just right. They're great for demonstrating how contrasts should sit next to one another – light areas directly next to dark areas for maximum impact.

YOU WILL NEED

Pencils

Warm Grey 1 (270)

Dark Sepia (175)

Skyblue (146)

Cold Grey 2 (231)

Black (199)

Payne's Grey (181)

Dark Indigo (157)

Warm Grey 5 (274)

White

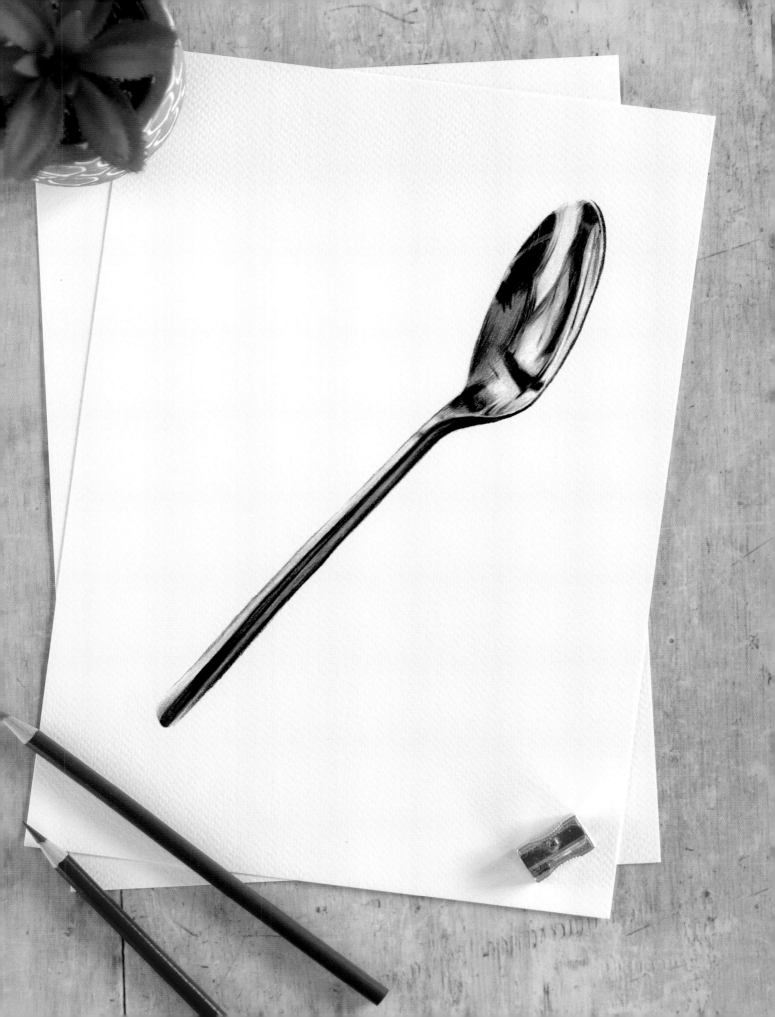

1 First, define the handle of the spoon, getting the sharp reflection lines in place. Using Warm Grey 1 with light pressure, cover the entire handle. Then, using Warm Grey 5, add in the dark reflections along the handle. Keep your pencil sharp and the lines neat and straight. Pay close attention to any reference material to ensure you maintain the form of the handle.

2 Using Dark Sepia and Dark Indigo, refine the handle by making the existing shadows darker. The blue tone here will help to produce a metallic look and provide some much-needed depth. Add a light layer of Skyblue to the highlights on the top side of the handle. On the underside, gently shade the lighter section with a layer of Dark Sepia and blend together by going back over with Warm Grey 1. The bowl of the spoon can also be filled in with a layer of Warm Grey 1, followed by a layer of Cold Grey 2 where the darker shadows lie. Maintain the curvature of the bowl by shading and following the curve of the outer lines.

3 Fill in the previously-defined dark shadows on the bowl of the spoon with Dark Sepia, making sure to pay attention to the curvature and any reflections. After this, fill in any mid-toned shadows with Cold Grey 2.

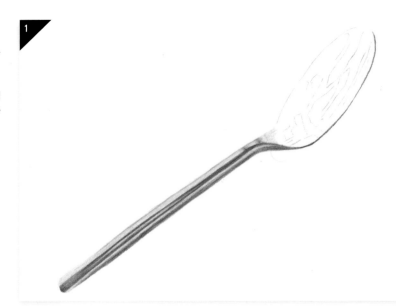

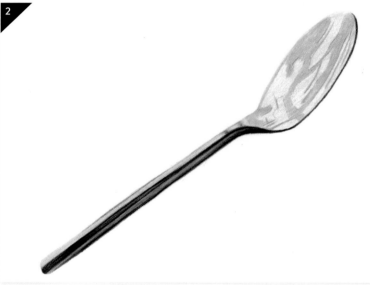

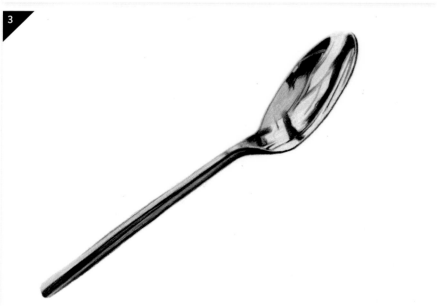

4 Using Skyblue, Dark Indigo and Payne's Grey, add blue tones around the edges of the darkest highlights. This will make the 'white' areas appear even more white and enhance the reflections. These three colours are also added into the dark shadows to help give them extra depth. The essence of the spoon is now complete, so we'll move on to the final details.

5 Using Black, add an extra layer to the dark shadows, follow this with Dark Indigo to create more depth. Dark Sepia is perfect for extra little details: use this pencil to smooth out any lines and create crisp edges. Add any additional shading or refining that you feel necessary – you can also use a white pencil to smooth out your white areas if you want a smooth, polished appearance.

TIP

Erase the graphite outline before layering coloured pencil on the spoon, especially where there are light colours on the edges.

TECHNIQUES USED
- Shading
- Layering
- Blending

Sweet Wrapper

—

Drawing sweet wrappers is all about depicting that high, glossy sheen. And recreating a glossy surface is all about keeping lines nice and precise and maintaining the contrast between light and dark. A white gel pen is a really handy tool to have here so that if you struggle to keep white areas white, you can easily add them back in.

YOU WILL NEED

Pencils

- Warm Grey 1 (270)
- Warm Grey 3 (272)
- Skyblue (146)
- Warm Grey 5 (274)
- Ivory (103)
- Raw Umber (180)
- Dark Sepia (175)
- White

Other tools and materials

White gel pen

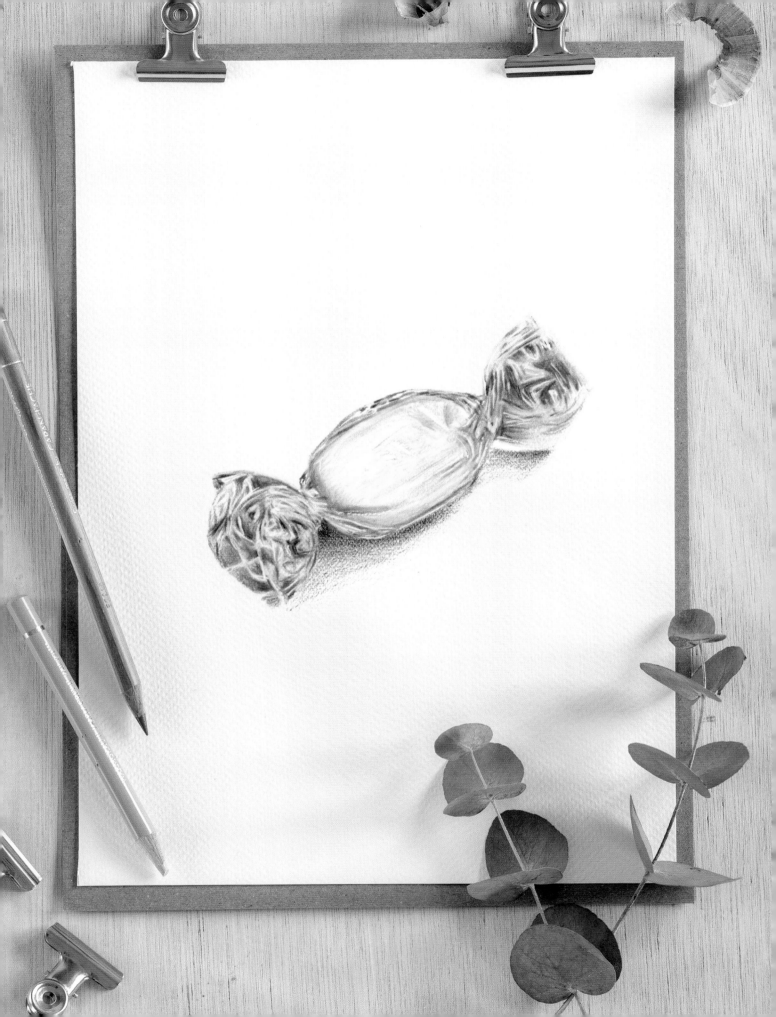

1 Start by blocking in all the main shadows with Warm Grey 3. Using light pressure, gently add in all the darker areas, paying attention to the shapes made by the shadows and mimicking them as closely as possible. Use firmer pressure where there are slightly darker shadows. Doing this will help to give form plus a structure for further darkening and highlights.

2 Use Warm Grey 5 to define the shadows even further. Leave a blunt edge around your pencil layers here as this will help to give the impression of sharp, shiny folds in the wrapper.

3 Colour the area containing the sweet using Ivory. Make small circular scumbling motions with your pencil to add in the colour. Take care to avoid adding colour to the highlights. Add a further layer of Ivory and then, in the highlighted sections, add a light layer of Warm Grey 1, followed by Skyblue to create a soft blue tone. Gently layer on Warm Grey 3 around the highlights to create an even shinier looking surface. Also lightly add Warm Grey 3 to the surface of the sweet, drawing small circles and leaving gaps in-between to mimic the slightly mottled appearance of the sweet's surface against the wrapper. If necessary, use Warm Grey 5 to create even darker shadows. I've used Raw Umber around the underside of the sweet to give it a more colour and depth. Just a light layer here is enough to convey the shadow and tone.

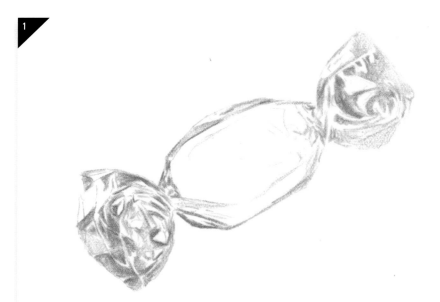

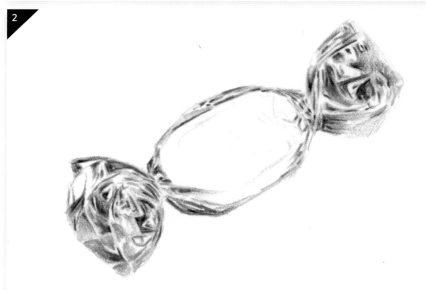

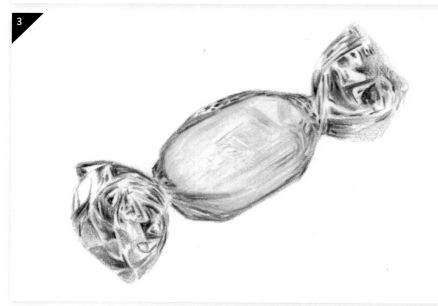

4 Add a layer of Warm Grey 1 to the end of the sweet wrapper, filling in the remaining white paper. Use Skyblue and Raw Umber to gently glaze over a few of the white highlights, adding in a slight tinge of colour. This will help to increase the shine. Use Warm Grey 5 to add more shadows and lightly touch this colour into the highlighted areas, mainly in the middle, leaving the outer edges of the small, individual highlights the brightest. You could also use a white pencil to add some white areas and to blend if your wrapper needs to look a little smoother.

5 Fill in a few more shadows on the edges of the sweet wrapper and where the wrapper is twisted around the sweet. Then you can use a white gel pen or a white pencil to add in the super-bright highlights.

6 Finally, add a shadow beneath the sweet to make it look as if it's sitting on a surface and not floating. Use a Dark Sepia pencil on its side to gently shade underneath. The shadow should be darkest directly beneath the sweet and gradually lighten the further away it is.

4

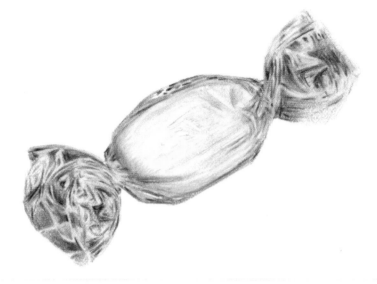

5

6

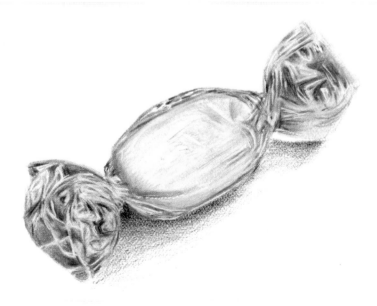

TIP

Try not to blend edges too much for this study as you want to maintain the crisp, shiny edges of the crinkly wrapper.

TECHNIQUES USED
- Shading
- Layering
- Blending

Ice in a Glass of Water

—

This is a more complex study, where it's necessary to factor in not only the reflections of the glass, but also how the water and ice interact with one another in the glass. This might seem daunting, but if you keep to mapping out shadows and highlights, everything will come together nicely.

YOU WILL NEED

Pencils

Warm Grey 1 (270)

Warm Grey 3 (272)

Cold Grey 3 (232)

Payne's Grey (181)

Van Dyck Brown (176)

Skyblue (146)

White

Other tools and materials

White gel pen

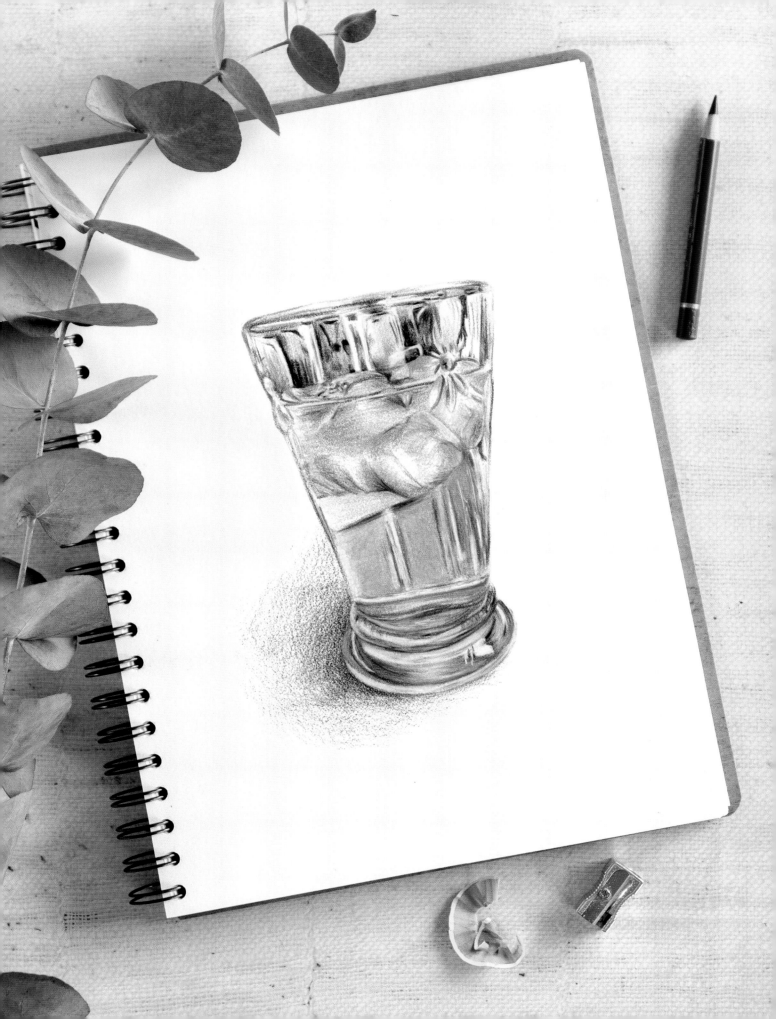

1 Start by erasing the graphite and, using Warm Grey 3, defining the darker parts of the glass and ice. A sharp pencil point will help you to get precise edges here. Add in the highlights using a white pencil and firm pressure to make sure you really get the pigment down and create a sort of resist for when you work with other colours on or near the highlight. The most complicated parts are around the base and the lip of the glass so pay attention to how the light bends along the curve of the glass and replicate that with your sharp pencil. If you have any areas of large, dark spaces, use Warm Grey 1 to lightly shade them in.

2 Starting at the bottom of the glass, gently shade in darker tones of Cold Grey 3, Van Dyck Brown and Payne's Grey. Brown is used here because the surface reflected in the glass is a wood brown. Using this colour helps to portray that and adds to the reflections and tones. There are identifiable ridges within the glass, which I have kept free of shading and where I have used a base tone of Warm Grey 1 to indicate that the surfaces are lighter. Directly around these lighter areas are darker tones, which help to make the light tones appear almost white. Add in small lines and details with a sharp Payne's Grey pencil and follow the curvature of the glass – paying attention to the light reflections, too – to create a scattered light effect. This type of texture is more apparent in intricate areas like the base of the glass.

3 Continue working your way up the glass, filling in all the shadows and leaving the highlights free from any pencil. Focus on the darkest areas and gently shade back and forth to create a smooth, even tone. When working on the next layer, shade in the opposite direction to create a sort of cross-hatch technique. This will help to fill the tooth of the paper and create a smooth look.

4 Complete the remainder of the glass by focusing on the upper part, again filling in the shadows using shades of grey and leaving the highlights free of any colour. There tend to be stronger shadows on the upper part of the glass. Make sure your highlights are nicely contrasted by placing the darkest colours directly next to them and creating sharp edges with a sharp pencil.

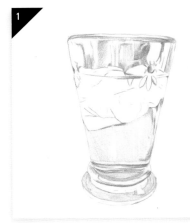

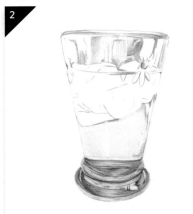

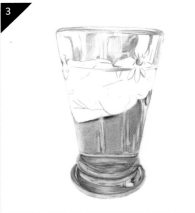

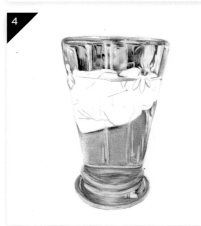

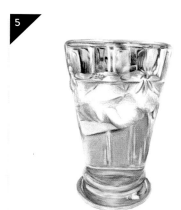

5 With the main aspects of the glass now in place, it's time to define the ice. Fill in the shadows first: these mainly occur where cubes are sitting next to one another and in tiny little cracks in the surface of the ice. For the shadows, use gentle layers of Warm Grey 3 to gradually build up the tone, lifting the pressure from the pencil as you work towards the centre of the cubes. The centre tends to be the lightest, most dense part of the ice. You can also add in a little Skyblue to create more of a white effect. Gently add the tiny cracks using the same pencil, but make sure the point is sharp so you can get precise lines. The top of the water can be shaded with Warm Grey 3, just make sure to leave a tiny white line right where the surface of the water touches the glass: this will give a three-dimensional effect.

6 Continue darkening and shading the ice with Warm Grey 3 and Skyblue and fill in any white areas using Warm Grey 1. Continue using a light pressure and gradually building the tones as this will help to add depth and will also naturally start to blend the piece. Use Payne's Grey to gently darken any prominent shadows and add in any fine detail lines.

7 Add a slight shadow around the base of the glass to give the subject a little context and to help define the light, reflective edges at the bottom of the glass. Use Payne's Grey with light pressure to gradually build the shadow. The shadow will be darkest directly underneath and beside the glass and gradually gets lighter further away. Create that soft, gentle gradation by lifting the pressure off the pencil and adding fewer layers to the outer edges of the shadow.

8 Finally, build up the contrast by going in with a sharp Payne's Grey Pencil and a white gel pen to add in any specific highlights that really stand out and appear the brightest. You can also use a white pencil, but for maximum white coverage, a gel pen is great.

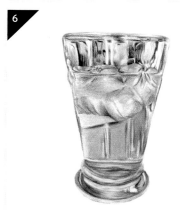

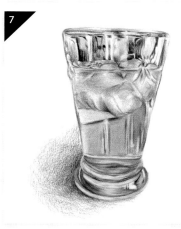

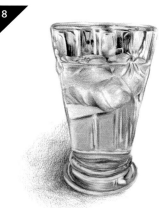

TIP

Reflections change based on the curvature of the glass. The lower half of the glass is rounded, and the highlights fall differently compared to the body of the glass.

Dog's Nose

—

A dog's nose is one of the all-important defining features for a portrait (along with the eyes) and requires a fair amount of shading and detail. Here, we'll look at how to layer your pencils from light to dark and how to create form and texture using some simple shapes and motions with the pencils.

YOU WILL NEED

Pencils

- Dark Sepia (175)
- Warm Grey 1 (270)
- Olive Green Yellowish (173)
- Skyblue (146)
- Caput Mortuum Violet (263)
- Cold Grey 6 (235)
- Walnut Brown (177)

- Dark Indigo (157)
- Nougat (178)
- Earth Green (172)
- Light Red-Violet (135)
- Black (199)
- Warm Grey 3 (272)
- White

Other tools and materials

White gel pen

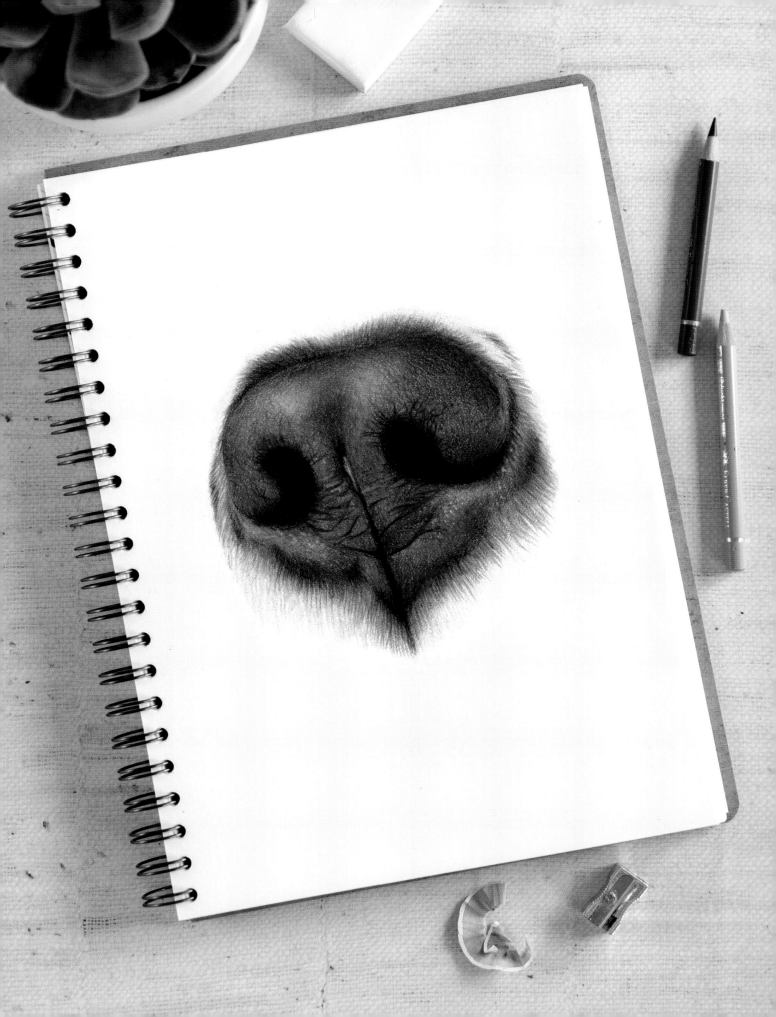

1 Start by using a sharp Dark Sepia pencil to outline the edges of the nose and define the nostrils and the middle of the nose. In most cases, the nostrils are upside-down teardrop shapes. Use light pressure to roughly map these in. Light pressure is crucial as it's much easier to erase than if you use a harder pressure. Once you're happy with the shape, gently shade in the nostril shapes using small circles. Once the nostrils are defined, shade the entire nose using Warm Grey 1.

2 Next, use harder pressure on the nostrils to really darken them. Add in the darkest parts first, so that you can judge the values of the rest of the area more easily. After darkening the nostrils, add the varying tones that are present in the nose. Using light pressure, add some Olive Green Yellowish to the middle and lower right, Skyblue underneath the nostrils and throughout the top middle, and finally, some Caput Mortuum Violet to the outer edges of the nostrils and both lower parts of the nose.

3 With the shadows in place, you can now start to darken and define the different tones. You should be using light pressure and shading back and forth in multiple directions or using a circular motion to cover as much of the tooth of the paper as possible. Using a combination of Cold Grey 6, Walnut Brown and Dark Indigo, add in the shadows around the edges of the nose, focusing on the lower half where the nose makes a natural 'v' shape. Shade in darker shadows at the top middle of the nose to indicate a very shallow valley. This will help to give the nose more form. Now, add Dark Indigo inside the nostrils to give them a little extra depth. A layer of Warm Grey 1 is also added to the outside of the nose to start giving the impression of fur.

4 Now, add some texture to the fur surrounding the nose. It's important to create a smooth blend between the nose and the fur to avoid making the nose look like it's just been stuck on. Using Cold Grey 6, work in small, tapered fur lines, making sure you lift the tip of your pencil as you work further down the fur line. Follow the direction of the fur all the way around the nose and don't make the fur lines too long. Group the lines close together to increase the saturation of colour. To create a blend, shade a little of the colour at the edges of the nose slightly into the fur lines just created. Use Dark Sepia to define the darker lines and details within the nose by lightly mapping out the lines coming from the centre line of the nose. To give a little curve to the nostrils, add some fine lines in a radial pattern around the dark nostrils.

TIP

White pencil is difficult to add over darks, so use a white gel pen to give the nose that wet, shiny look.

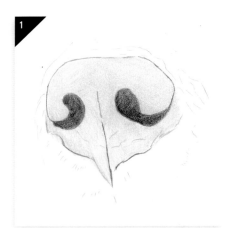

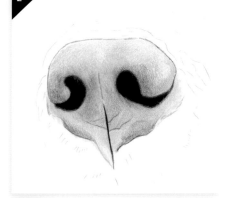

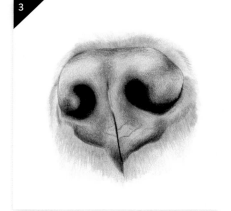

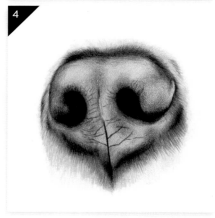

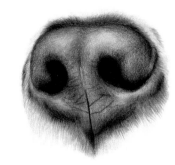

5 Focusing once again on darkening the nose, use a mixture of Walnut Brown, Nougat and Dark Indigo to strengthen the shadows and start to fill in the mid tones. Dark Indigo is mainly added around the highlighted areas at the top of the nose. Walnut brown can be used on top of this to create an even darker area where needed. Use Nougat to tone the entire nose and bring up the mid tone values. Use a light pressure and shade gently to build a nice, rich colour. You should still be able to tell the difference between the lights, darks and mid tones. If you find you're losing the darker tones, go in and shade them gently – along with the mid tones – so you still have that definition.

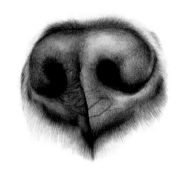

6 It's now time to push the mid tones even further and continue to darken. In this step, half of the nose is shaded so that you can see the difference in values. Shading has mainly taken place around the highlighted area and alongside the centre of the nose. A combination of Walnut Brown and Dark Indigo layered on top of one another creates a nice, dark tone. This is accented with Earth Green and Light Red-Violet; layering these around the nostrils helps to strengthen the mid tones and add more distinction. Another layer of Skyblue has been added and Dark Indigo has been lightly shaded on the highlighted sections of the nose – Skyblue through the middle and then Dark Indigo around the edges and blended into the darker tones. Alongside this process, it's important to use the Dark Sepia pencil to darken the fine lines and little details.

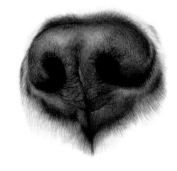

7 Following the same process as in Step 6, shade the other side of the nose. This side is more in shadow, so take it a little darker. Using the Walnut Brown, Dark Indigo and Dark Sepia, use a gentle shading motion to work over the entire remaining area. Working lightly and slowly, build the colour; this ensures even colour, but also allows you to build a lot of depth. As before, add some greens and purples into the mid tones and shadows to help to build the depth even more. Use a sharp Black pencil to add in small details and lines around the nostrils and edges of the nose. I also use Black to gently shade into the shadows, and lift the pressure even more to work into the mid tones. This helps to create a gradual blend between the tones.

8 Gently blend all over to remove any graininess and create a solid appearance. To do this use Nougat for the darker tones and Warm Grey 3 for lighter tones. Work gently over the whole of the nose until everything looks smooth and well transitioned. There may still be some slight graininess to your image, but I find that adds to the texture of the nose. To bring out the details, again take the Black pencil (with a sharp point) and add in the fine lines. Use a white pencil to add small highlights. These should be placed where the nose catches the light – around the underside of the nostrils and around the large highlights at the top. I've also added a few throughout the middle to give the impression the nose is in two parts. Make sure the pencil is sharp and work gently at first, adding more pressure if necessary. Use a white gel pen if needed.

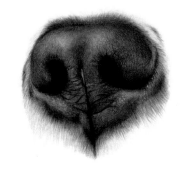

TECHNIQUES USED
- Shading
- Layering
- Blending

Dog

—

There's a lot to think about when it comes to a full-body subject. I approach this type of piece methodically: putting in prominent features first and then working over the entire subject adding the shadows, mid and dark tones, before going back with the lighter tones.

YOU WILL NEED

Pencils

- Black (199)
- Dark Sepia (175)
- Van Dyck Brown (176)
- Warm Grey 1 (270)
- Warm Grey 2 (271)
- Nougat (178)
- Burnt Sienna (283)
- Caput Mortuum Violet (263)
- Burnt Ochre (187)
- Cream (102)

- Grass Green (166)
- Permanent Green Olive (167)
- Earth Green (172)
- Olive Green Yellowish (173)
- Beige Red (132)
- Salmon (130)
- Burnt Carmine (193)
- Sky Bue (146)
- Cold Grey 4 (233)
- Ivory (103)

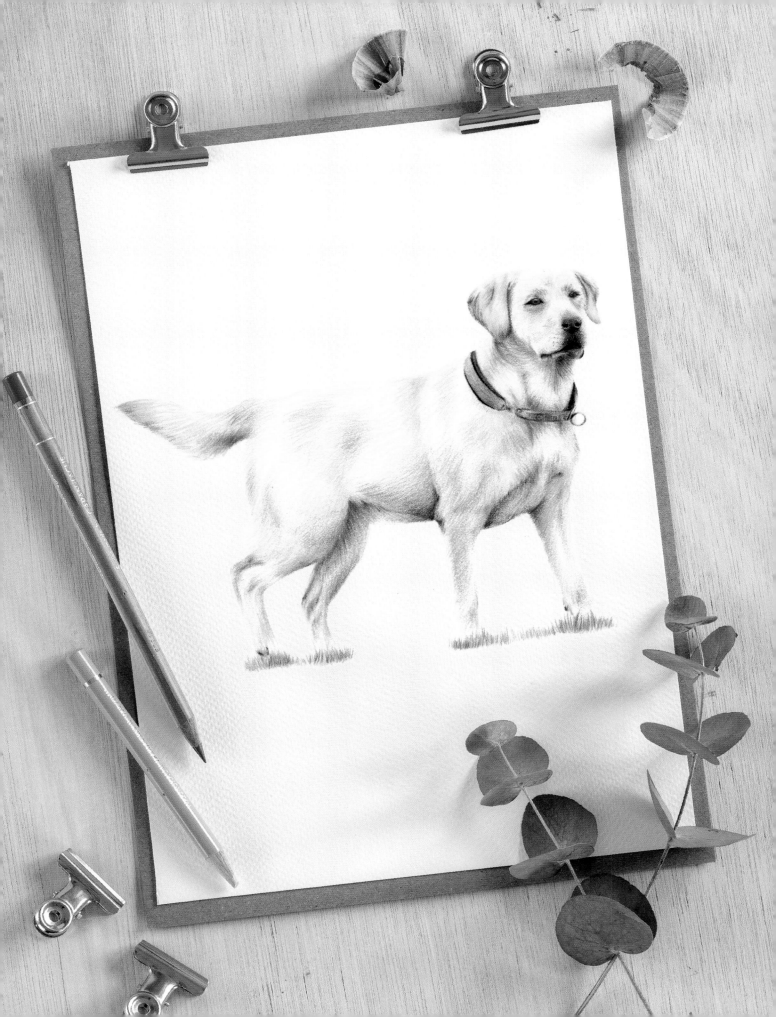

1 Start by putting in the main facial features. Using Dark Sepia and Van Dyck Brown, add outlines for the eyes, nose and mouth (define the pupils and nostrils as well) and once you're happy, add a second layer using a slightly firmer pressure to solidify the lines. Use Warm Grey 1 for any highlights in these areas before using Nougat to add in a light layered mid tone. For the eyes, use layers of Nougat, Burnt Sienna and Van Dyck Brown to build up the tones. In this example the eyes are quite dark so you can exert a little more pressure on the pencil. Take the same approach with the nose but add some Caput Mortuum Violet to the top of the nose. Make sure to maintain any light areas within the nose to keep it looking nice and shiny.

2 With the features in place, you can start to define the shadows on the head and neck. Use Warm Grey 2, Burnt Ochre and Nougat to shade the areas around the eyes, ears, muzzle and collar. Follow the direction of the fur in all these places, keep your pencil strokes light and use a shading motion. The most challenging areas to draw are around the neck as there are some confusing folds and tufts of fur. Take your time in these areas and use light pressure so that you can erase any mistakes if necessary. The inside of the collar requires darker shading, so use some Dark Sepia and a harder pressure to add a semicircle of shadow.

3 Take the same colours – with the addition of Earth Green and Olive Green Yellowish – and using the same approach as for steps 1 and 2 further define the shadows through the front legs and belly. Layer up the shadows first by using Warm Grey 1 and getting darker, or just go straight in with a darker colour. Bear in mind that there are different tones of shadow all over, so the shadows won't all contain the same colours. The shadows around the neck are lighter than those between the legs and on the belly. The area between the legs will require more Van Dyck Brown and the addition of the greens. We're adding in green here as the dog is standing on grass (which will be added at the end) and it's also a great colour for shadows on dogs of this colour. Always follow the directions of the fur and use the soft, shading motion.

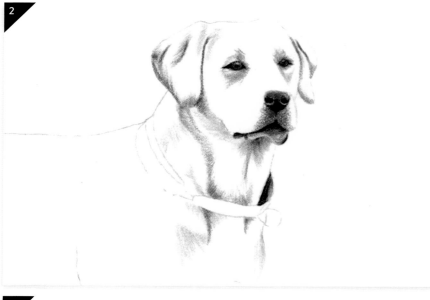

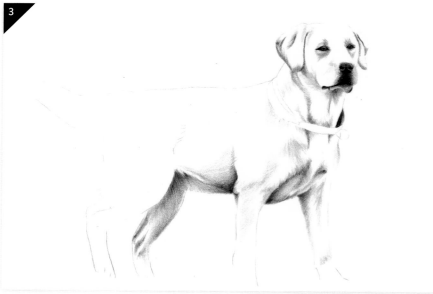

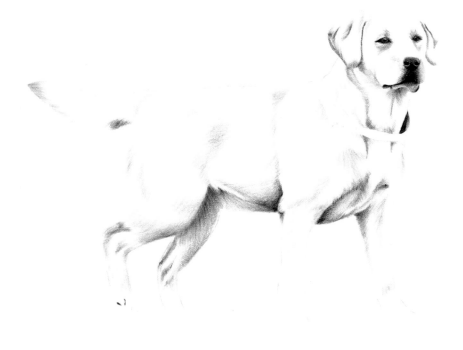

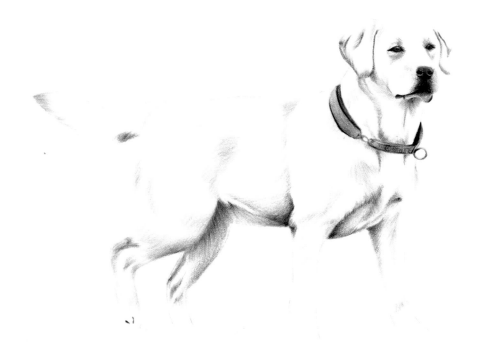

4 Continue as before, working on the shading across the whole dog, remembering to ensure the shadows between the legs are the darkest. There should be a clear difference in tone between the top and bottom halves of the dog. The darkest points so far are the features, the inner leg shading and then the remainder of the shadows.

5 Before we get to the fur, add the collar in. Layer a base of Warm Grey 1 across the whole of the collar, making sure to add the chrome rings. The chrome effect is achieved by using Dark Sepia around the edges and lifting the pressure right off the pencil to blend into the centre of the ring. The darker areas of the collar are rendered using a mixture of Van Dyck Brown, Burnt Sienna and Dark Sepia. To create a smooth texture, use a circular motion with the pencil and blend using Warm Grey 1. Use the same technique for the pink: layer in some Beige Red, followed by Salmon and then a light layer of Burnt Carmine. Blend them using Warm Grey 1 and add in a few shadows using Skybllue, which will create a darker purple tone. There's a slight pattern on the collar so use Earth Green and Cold Grey 4 to depict this, drawing small squares to mimic the pattern. Make sure the collar is nice and smooth by using small circles and gently blending with the lighter tones.

6 With everything defined and roughly added in, you can now start to put in the light tones and blend the shadows together. Most of the fur will be drawn using Warm Grey 1 and Ivory, with some of the other colours used to develop and blend the shadows. Starting with the face, add some Ivory around the eyes and nose and into the ears. Add Warm Grey 1 to the sides of the head and around the nose. Overlap these two colours and gently lift the pressure of each as you work into the respective area. Using a mix of Warm Grey 2 and Beige Red with light pressure, blend the existing shadows around the eyes, nose and mouth, gently layering to achieve a smooth blend. You can also use some darker tones if you need to blend over even more. The ears require more mid-tone shading with Burnt Ochre to get that bright, almost orange, tone. Some Beige Red in these areas will also help to achieve the apricot tone that is often seen in this fur type. Most of the fur and redefining of the shadows is achieved using a shading motion, but one or two fur strokes can be added in using Van Dyck Brown to convey the idea of texture.

7 Continue to add the light-toned fur on the neck and front legs. When adding lighter tones in these areas, shade right over the existing shadow as this will help to blend and will also transfer a little of that darker colour into the lighter tones as you shade back and forth. Add a little Skyblue into some of the shadows and blend into the lighter tones. Blue worked over the yellow or cream will help to accent the yellow tones and creates a natural-looking shadow. Use some of the darker tones to blend the existing shadows into the lighter-toned fur.

8 Continue the light-tone fur shading throughout the middle section and rear legs, shading over the existing shadows to help with the blending once again.

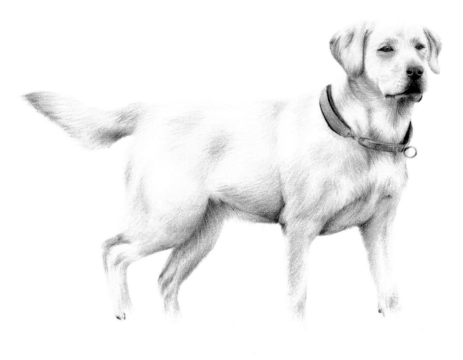

9 Finish the light-tone shading on the tail. For this section, use more Burnt Ochre and Beige Red tones to blend out the shadows and hint at that slightly different fur tone as you did with the ears. At this stage you can look over the whole drawing and, if necessary, make adjustments to the shadows and perfect any blending transitions. You may have noticed that we haven't added in many fur details and lines. This is because the fur on this dog is very short and doesn't need that level of definition. The idea here is to convey the shadows effectively to create the muscular appearance of the dog, rather than focusing on minute details that detract from the overall body.

10 To give the dog some context and so the green tones in the shadows make sense, add some grass under the feet. Start with a small layer of Warm Grey 1 around the base of each foot, bringing the two front paws and the hind paws together. I've left a gap in the grass under the belly but feel free to create a continuous row if that's what you think looks best. Take a sharp Permanent Green Olive and create small blades of grass by drawing a tapered line and overlapping the feet a little towards the tip. Make these lines a variety of different lengths to mimic the varied lengths of grass. Do this for both the front and hind feet and group the lines you're making quite closely together to get a deeper saturation of colour. Now, use Grass Green to gently shade over and in the direction of the grass to add tonal variety. Next, use Olive Green Yellowish to add some darker blades of grass, this time spacing them out, to add to the tone variety. Finally, add a few grass blades using the Black pencil but make sure to use this very sparingly and keep the strands even further apart than before. Run a final check over the dog and make sure the shadows are looking great, make any adjustments as necessary and that's it!

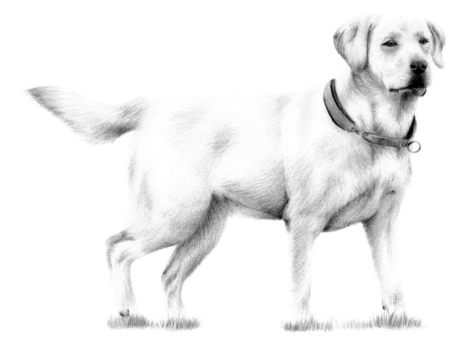

TECHNIQUES USED
- Shading
- Layering
- Blending
- Embossing

Cat's Ear

—

Cats' ears are simple to render and I'm going to show you a little trick you can use to make the white, overlapping fur easier to produce. If you use an embossing tool to indent the paper you can create smooth grooves that allow you to add pencil layers over the top. Your pencil will just glide over the indents, leaving them smooth and crisp-looking.

YOU WILL NEED

Pencils

Ivory (103)

Warm Grey 1 (270)

Cinnamon (189)

Nougat (178)

Burnt Ochre (187)

Terracotta (186)

Burnt Sienna (283)

Purple Violet (136)

Black (199)

White

Other tools and materials

Embossing tool

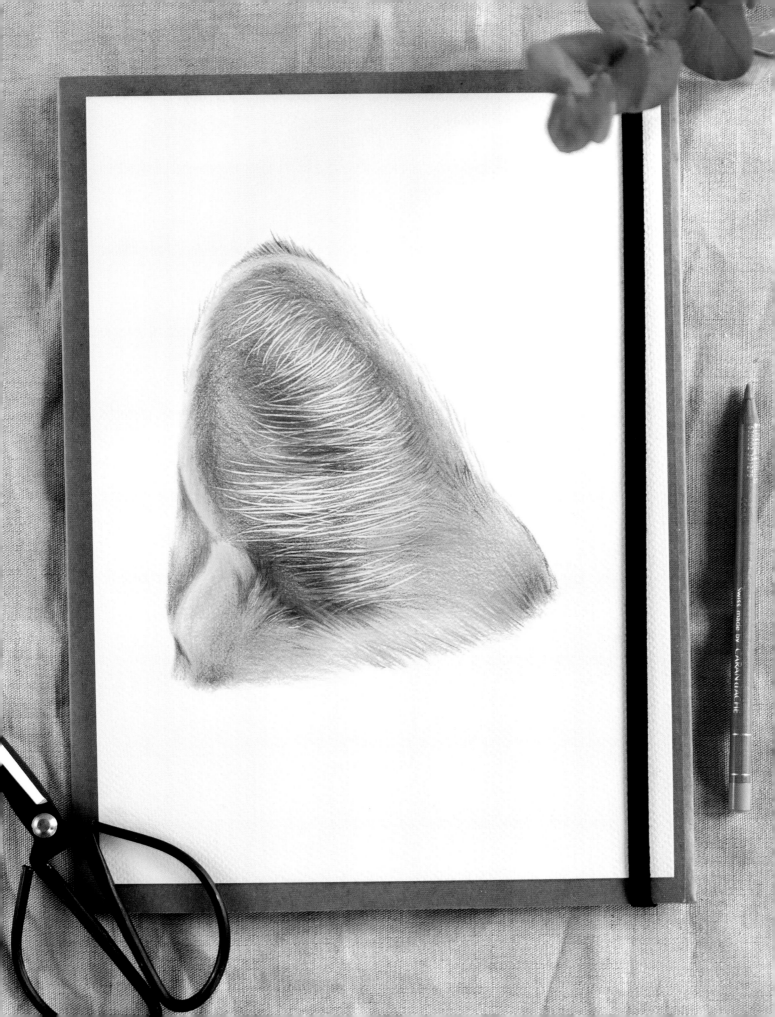

1 Before you put any colour down, use the embossing tool to indent the paper. Make sure to use a firm pressure so that you indent the paper enough. Light pressure will not indent deeply enough, and the lines will be covered by the coloured pencil layers. It's a good idea to practise this method on a scrap piece of paper first so that you become familiar with the amount of pressure needed for your lines. When embossing your working paper, take care to indent the lightest parts of the ear and to follow the fur direction. These light 'tufts' tend to come out from the inner edge of the ear and towards the middle. Taper the lines by lifting pressure from the embossing tool, as you would when drawing fur.

2 Next, start to add in the base tones for the fur. Ivory makes a good base for the entire ear and is added to most areas, except the lightest parts of the inner ear tufts (the area indented with the embossing tool). Then, working over the top of the Ivory, add a layer of Warm Grey 1 to the areas with the deepest shadows: this is mainly the ear folds and the lower inner ear. There's also a considerable amount of darker tone around the edges of the ear as this is where the fur is a little darker, so put down some Warm Grey 1 here, too. Throughout the entire base-layer process, make sure you layer in the pencil in the direction of the fur. There are quite a few fur direction changes throughout the ear, so pay close attention to your reference images.

3 Continue to work on the darker tones so that you can really see the shadows and start to see the proper form of the ear. Using Cinnamon, shade over the areas of Warm Grey 1 added in step 2. This will create a soft apricot tone, a perfect base for future colours. Use Nougat to darken these areas further, and continue to build colour and blend with Cinnamon and lighter colours if necessary. You should start to see some really defined points on the outer edge of the ear and in the centre of the inner ear. Around the bottom edge of the ear are some strong darker tones overlapped by soft, lighter-toned fur. To draw these, use Nougat to gently work backwards from the dark inner ear into the light fur. This will create a natural looking separation of the fur strands. Vary the line length for an even more natural effect. Use the same technique to work into the light tufts of the ear, too.

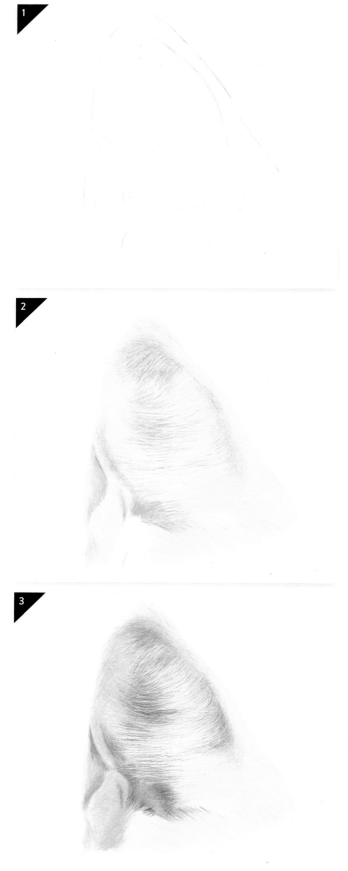

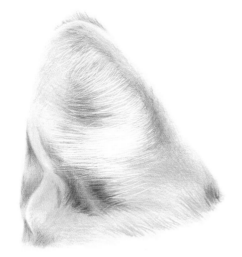

4 Next, work on defining the darker parts of the ear by introducing Burnt Ochre, Terracotta and Burnt Sienna. As always, take care to follow the direction of the fur. Work gradually and in a more circular motion in the inner ear to create a smooth appearance – this part of the ear is hairless and smooth. Add some white fur lines in the dark inner ear, taking them backwards into the direction of the fur, to maintain the natural overlap of the white fur at the bottom and to the right. Use Burnt Sienna lightly and sparingly. It can be quite a saturated colour and you only need a few hints because the darker sections will be toned with purple. Purple and orange is a fantastic combination: the purple accentuates the orange tones and helps create a more dramatic shadow tone. Add Purple Violet to the dark inner ear. If at any point you're a little confused about where your darker tones are and where you should be adding these colours, squint at your reference material and it will become a lot clearer.

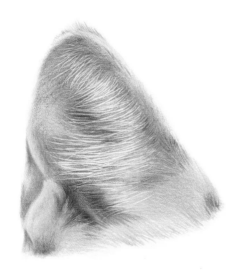

5 Using the same colours as in previous steps, exert a little more pressure on the pencil and start to add in some detailed fur lines to bring the colour and texture to life – darkening the shadow tones and evening up the mid tones to match. Start with Burnt Ochre and gradually get darker around the outer edges of the ear, gently lifting the pressure and blending into the lighter tufts through the middle. Add more Nougat at the top of the ear and pair it with the Purple Violet to create a unique shadow tone. I've also lightly added the Purple Violet into the white tuft area to help spread the colour out. Adding purple into white makes white appear even brighter. The lower section of the inner ear is pretty much there in tone now but a few more layers of Burnt Ochre and Burnt Sienna will help to smooth the area out and add depth. The left mid ear is where most toning happens at this stage as everything is blended to create seamless colour transitions between the areas.

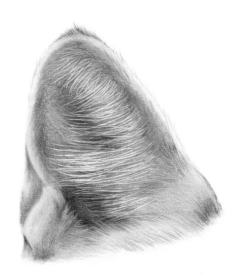

6 It's finally time to add a few darker colours, such as Burnt Sienna, Black and Purple Violet. Look at your drawing and see if you notice any areas that don't look very three-dimensional or need more shading. This may be tricky but try out the squinting method to see if it helps. At this point, I added Purple Violet into the darker areas and into the white tufts to make them look even more white, using the pencil on its side to apply extremely light pressure and to get between the embossed lines. I also used Nougat and Burnt Ochre in the same way to help with the transition of colours through these tufty areas. Black was added very lightly into the lower inner ear to create more shadow and give the impression that the ear has depth. This also makes the white hairs look very prominent. Then, it's just a case of adding more Terracotta and Burnt Ochre tones with a harder pressure to increase the mid tones and build a brighter, orange-toned fur.

TECHNIQUES USED
- Shading
- Layering
- Blending
- Glazing

Cat's Eye

———

Drawing a cat's eye requires the use of two techniques: using small circles to create a smooth surface and adding in fur lines and impressions around the outside. The iris takes shape quickly and is created by adding a series of very light layers of colour. Circular pencil motions help to build texture.

YOU WILL NEED

Pencils

- Dark Sepia (175)
- Warm Grey 1 (270)
- Walnut Brown (177)
- Cream (102)
- Cold Grey 5 (234)
- Light Green (171)
- Dark Naples Ochre (184)

- Terracotta (186)
- Olive Green Yellowish (173)
- Earth Green (172)
- Skyblue (146)
- Dark Indigo (157)
- Black (199)

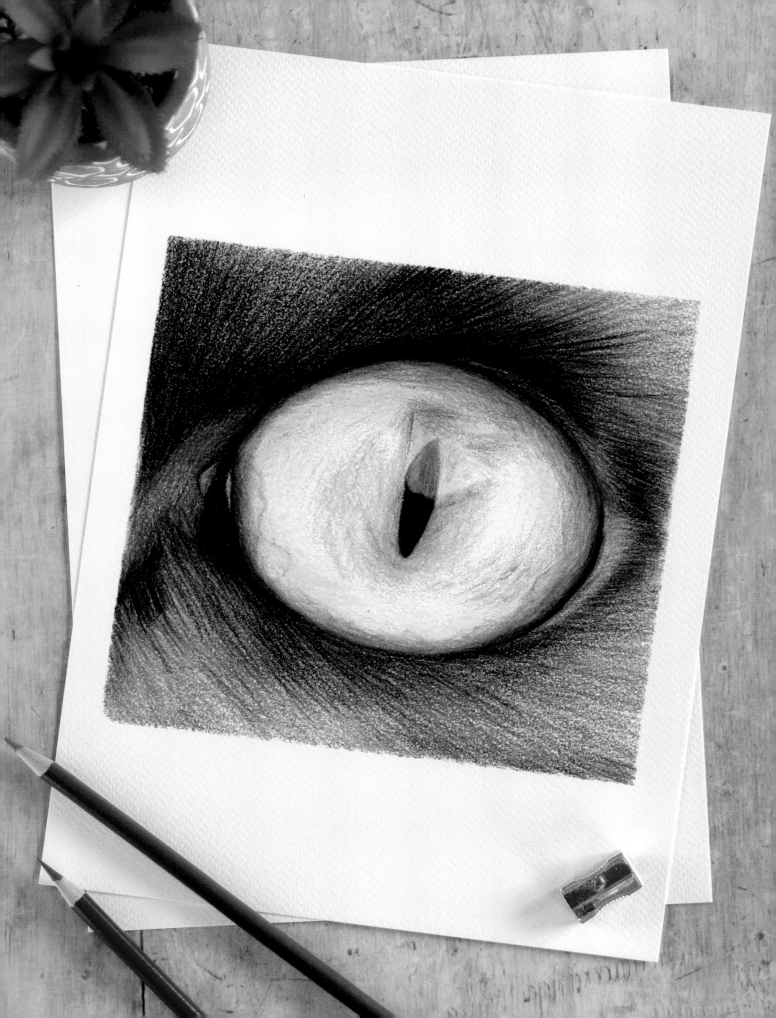

1 Get started by drawing in the basic eye shape. Use a sharp Dark Sepia pencil to lightly add in the shape of the iris, tear duct and the pupil. Once you're happy with the shape, use firm pressure to strengthen the outer lines and add some shading to the tear duct and pupil. In this case, half the pupil is covered by a highlight, so the top half is kept free of any shading for now.

2 Continue to work on the shape of the eye by adding the inner and outer eye corners. Use Warm Grey 1 to layer the base and then Walnut Brown to shade, using the side of the pencil very lightly over the top of the grey shapes just defined. Use Warm Grey 1 once more over the top to tone down the brown and to blend and smooth. Next, use Cream to shade the base of the iris using small circular motions and very light pressure. The aim is to establish a light, smooth layer all over and then go in with a secondary layer to define some of the darker sections, which are mainly around the outside edge and into the middle. Remember to leave the paper white above the top half of the pupil and to the upper right-hand side to define the highlight. Generally, the lightest part of an iris is through the very middle, going around the pupil in a radial pattern. The exact positioning is down to the direction of the light, but in this example, it's in the middle on the lower half underneath the pupil.

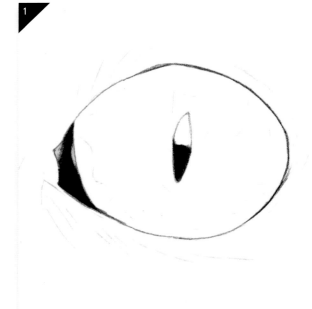

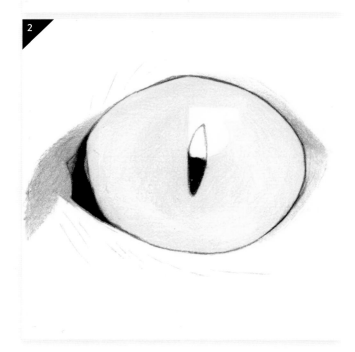

TIP

Use a small circular pencil motion when shading the iris to maintain the smooth, glossy texture.

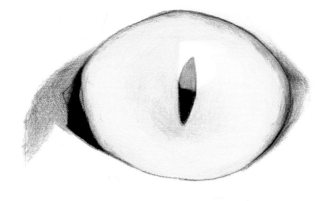

3 Darken the inner and outer eye corners with a Walnut Brown pencil, on its side. Cold Grey 5 can also be used on the outer corner to define a cooler area where the light catches on the waterline. Blend over both areas with Warm Grey 1. Add another layer of Cream to the darker parts of the iris around the pupil and the outer edges. Then take some Light Green and, using the small circular motion, add light layers, slowly building the colour in the centre and around the outer edges. Shade into the top half of the pupil using Dark Sepia and then blend over with Warm Grey 1 to dull the tone.

4 Continue darkening the iris. Start by adding Dark Naples Ochre, Terracotta and Olive Green Yellowish to the outer edges of the eye: concentrate on the shadows above the pupil, the highlight and each eye corner. Add a more prominent layer of Terracotta around the edges of the highlight, making sure to keep the edges crisp and square. Follow this with a little more Cream through the entire iris area, strengthening the light tones. Using harder pressure, add Light Green to the area around the pupil, followed by some Earth Green to add cooler, blue-toned greens into the iris. At this point, add a light glaze of Skyblue to the whole area of the highlight and blend with a light layer of Warm Grey 1. Keep the pressure extremely light. Use Terracotta to add in some iris eye markings, making them as wavy as possible to create a natural look.

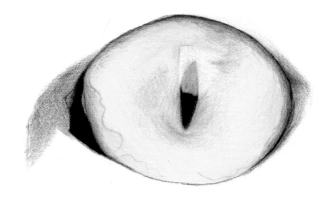

5 Start to add the fur around the eye using Warm Grey 1. Shade in the direction of the fur. Above the eye the fur goes upwards, and to the right as you go over the eye. Below, the fur points down and to the right. Follow the curvature of the eye as you put the layer down. Now, add a second layer of Warm Grey 1, increasing the pressure, and shading into the darker areas or shadows of the fur. If necessary, work a further layer of Dark Sepia into the inner eye corner, around the edges of the iris and into the pupil to maintain the dark tone. These are the darkest areas and will need to be worked on constantly to help them stay true and dark.

6 Now, add a light layer of Cold Grey 5 to the entire fur area, working in the same way and in the same directions as in step 5. Work from the very edges of the eye and from the inner and outer eye corners. Add a second layer of Cold Grey 5 into the shadows around the eye corners and eyelids; keep the same shading motion and keep the pressure as light as possible.

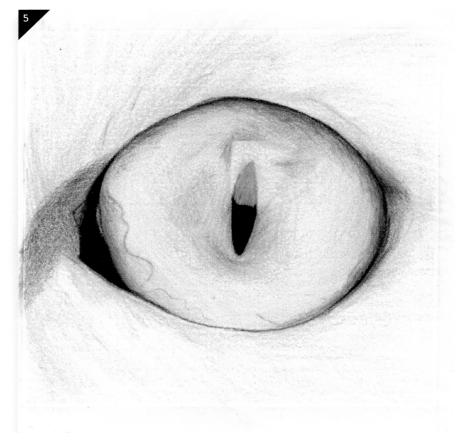

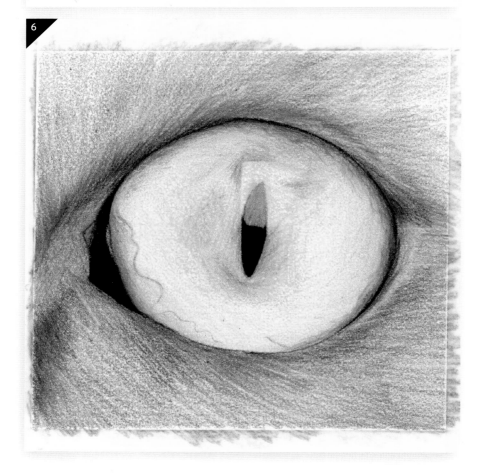

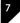

7 Start filling in the rest of the fur, going darker by using Dark Sepia. Begin with a light layer of shading before going in with individual fur lines. Group the fur lines closely together to create a dark saturation of colour. The darkest areas are around the inner eye corner, going up towards the eyebrows and along the upper eyelid. If necessary, increase the pressure here to get the colour dark enough. Add some Walnut Brown and Dark Indigo tones into the black fur to create more depth in these darker areas. As well as adding in individual fur lines, use the sides of the pencils to gently shade and create a glaze of colour over the top of the Dark Sepia. I also like to add a little Skyblue into the lighter fur areas to create a little bit of sheen. Do this by lightly glazing the colour over the top. Continue to darken the inner eye corner using Walnut Brown and Cold Grey 5 and re-saturate the pupil and other dark areas with Black.

8 Add a few more layers into the iris and really saturate those colours, especially around the outer edges, as this will make the eye look more spherical. Combine Walnut Brown and Olive Green Yellowish around the edges to create a darker edge, even adding in a light touch of Dark Sepia at the very edge to give that impression of a curve. Earth Green is a good colour to add into some of the tiny little details and nuances within the iris. Make sure the pencil is sharp so that you can get precise lines and a good saturation of colour. I also add this colour into the highlight to blend the blue tinge into the green of the eye. Use a sharp Walnut Brown to outline the edges of the highlight and shade back into the top of the iris. Continue to make small adjustments, gently adding in layers of the darker colours and adjusting any mid tones until you're completely happy. The aim is to have dark iris edges and a lighter tone through the middle, getting darker towards the pupil and around the highlight.

Cat's Face

—

I love drawing cats as they present a whole bunch of different fur-rendering opportunities, and no two cats are ever the same! I've chosen a tabby cat for this project as tackling some difficult-looking fur will give you an good opportunity to practise your hair and fur skills.

YOU WILL NEED

Pencils

Burnt Umber (280)

Dark Sepia (175)

Ivory (103)

Cream (102)

Earth Green (172)

Juniper Green (165)

Green Gold (268)

Cinnamon (189)

Burnt Ochre (187)

Burnt Carmine (193)

Warm Grey 1 (270)

Warm Grey 3 (272)

Raw Umber (180)

Nougat (178)

Walnut Brown (177)

Burnt Sienna (283)

White

Other tools and materials

Embossing tool

White gel pen

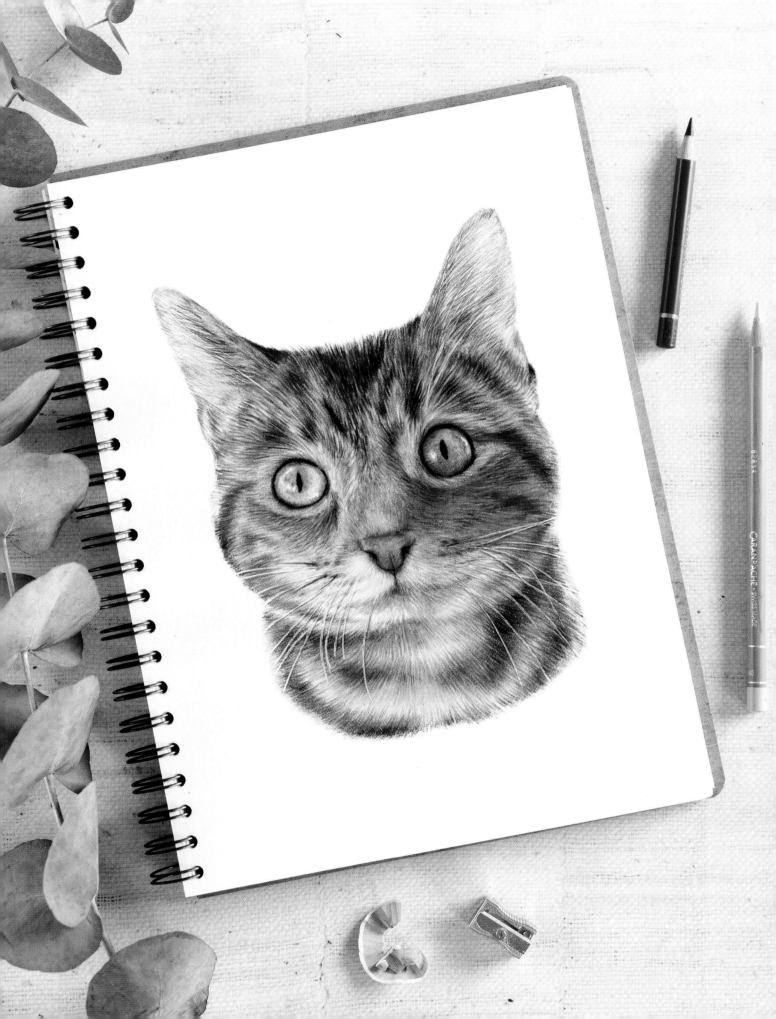

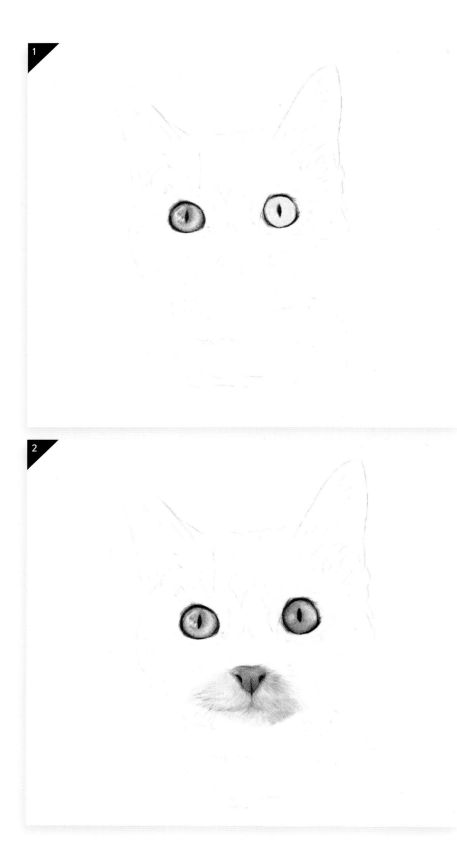

1. First, use Burnt Umber to define the eyes. Outline the edges and the pupil and then go over them with Dark Sepia to darken. Add a base layer of Ivory to the iris, making small circular (scumbling) motions with light pressure to achieve a smooth, even coverage. Avoid highlighted areas, just leave the paper white. Follow the Ivory with Cream, focusing layers of this around the edges of the iris and around the pupil. Add Earth Green, Juniper Green and Green Gold, again focusing the darker colours around the edges of the eyes where the shadows are. The base layer process is visible on the right-hand eye and then more of the darker layers of green are in place on the left eye for comparison.

2. Next add the nose. Using a light circular motion, start filling the darkest parts of the nostrils with Burnt Umber. Then take an Ivory pencil and fill in the entire nose with a light base layer. Maintaining the light pressure, add a layer of Cinnamon over the top. Darken the nose using Burnt Ochre and Burnt Carmine. With the layers in the nose built up, add the surrounding white fur, starting with a layer of Warm Grey 1 and working in the direction of the fur as it curves around the nose and into the lower jaw. Add a layer of Warm Grey 1 to start off the darker tones, followed by Warm Grey 3, a little Cinnamon, Burnt Carmine and Raw Umber. Use all these colours really lightly in a shading motion to build up the shadows.

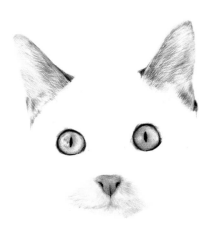

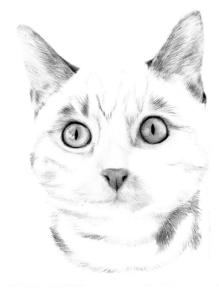

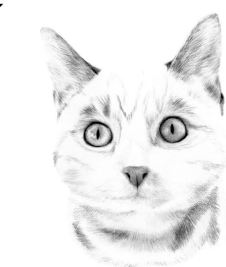

3. Use the embossing tool to add some embossed lines to the inner ear to represent the tufts of light fur that are found there. Now add a layer of Warm Grey 1 to the entire area, making sure to follow the fur direction. Continue to layer up the ears, referring to the Cat's Ear project for more details on techniques. The colours in both ear drawings are the same for the inner ear, but the outer ear here contains more browns than oranges.

4. Map out all of the darker markings using Burnt Ochre (for the slightly lighter areas), Nougat and Burnt Umber. Draw the shapes in lightly, making sure to add small hair lines in the direction of the fur. Where you have light sections overlapping the dark, work in the opposite direction – from dark to light – to create that overlap.

5. Apply a base layer of Ivory over the entire portrait, again working in the direction of the fur. Keep your shading light and work over several layers to build up the light Ivory tone. There are a few areas where the fur has a slightly cooler tone, in these places, shade over a little Warm Grey 1 to reduce the warmth of the Ivory.

6. Fill out a few more mid tones using Burnt Ochre and adding a mixture of Cinnamon and Ivory to create a peach colour, which is the perfect accompaniment to the orange tones in the fur. Use a shading motion mixed with fur lines to build depth and texture.

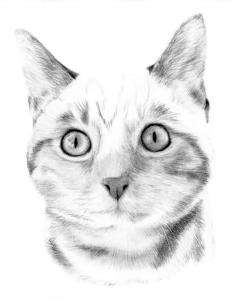

7. Use Nougat to gently add a mid tone to the forehead, then use Burnt Umber, Walnut Brown and Dark Sepia to add the darker markings on this area. To create these darker, flecked markings make sure that, for your lighter layers, the fur strokes are concentrated closer together. As you work towards the darker colours, gradually increase the distance between the fur lines so that you can still glimpse the lighter fur shining through. This will give the flecked appearance. Glaze a little Raw Umber over the forehead to give the fur a more yellow tone and to help tie in the ears to the rest of the fur.

8. Add more layers of Burnt Ochre, Burnt Sienna and Burnt Umber to the cheeks and around the eyes and the nose. Use small fur lines, beginning with the lighter colours and then building up to the darker ones. The idea is to build up as much depth as possible, so add as many layers as you can, making sure to keep your marks really light, but getting slightly heavier as you go through the colours to the darker tones. Keep a fair amount of space between the fur lines, especially the darker colours, to keep that flecked, tabby look. In the image for step 8 I've filled in the left-hand side but not the right, so that you can see the difference.

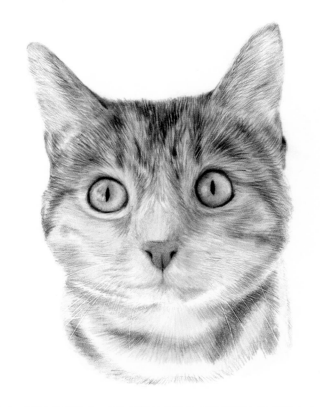

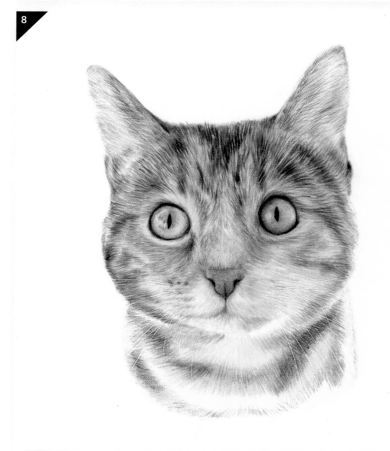

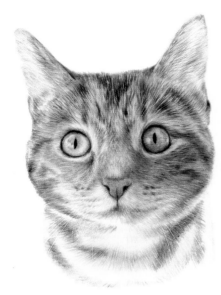

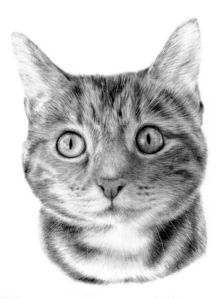

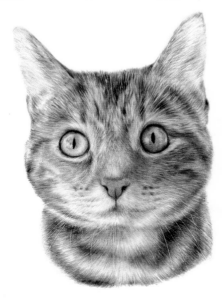

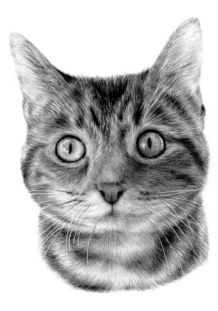

9. Fill in the other side of the face using the same technique and colours as used in step 8; however, this side is more in shadow so everything needs to be a little darker than it is on the left side. Refine the white around the mouth by adding in more layers of Earth Green and light layers of Dark Sepia to add touches of shadow. I've also darkened the right eye by adding in a few layers of Walnut Brown, Dark Sepia and Green Gold. The left eye is ever so slightly brighter, so darkening the right eye will not only brighten the left but will also tie in more to the darker fur.

10. Darken up the stripes around the neck using Burnt Umber, Walnut Brown, Burnt Sienna and a touch of Dark Sepia. Follow the fur direction as it curves around the neck and use longer fur strokes as the fur is thicker and longer here. Where you have several different colours all overlapping, work in both the direction of the fur and against the direction of the fur to achieve a nice, natural-looking overlay. You can also vary the length of your lines slightly as this will make the fur look even more natural. You may need to use a little more pressure on your pencil as you work towards the darker colours.

11. Finish off the lighter fur of the neck using Cream and Raw Umber, and a little Walnut Brown for the shadows. Concentrate the darkest parts directly where another patch of fur overlaps. This will create a natural look as the fur tends to fall in little clumps one top of the other in this particular area. Concentrate the shading with Walnut Brown underneath the chin so that you give the impression that the face is further forward than the neck.

12. Finally, add any small details that are needed and make adjustments to the entire portrait with colour glazes. If necessary, redefine the whiskers with a white gel pen or sharp white pencil to really make them stand out. I've also added a few black whiskers with Dark Sepia for added contrast. You can also lightly underline the whiskers (on the lower edge) to make them appear brighter and to make them stand out against the fur.

TECHNIQUES USED
- Shading
- Layering

Feather

—

This feather drawing is actually fairly easy to replicate. If the hollow shaft in the centre is well defined and the feather fronds form a 'V' pattern all the way along the central line, you have the beginnings of a great feather. As with most subjects, the form of the feather comes from careful shading.

YOU WILL NEED

Pencils

Warm Grey 1 (270)

Skyblue (146)

Warm Grey 2 (271)

Warm Grey 3 (272)

Earth Green (172)

Warm Grey 5 (274)

Ivory (103)

White

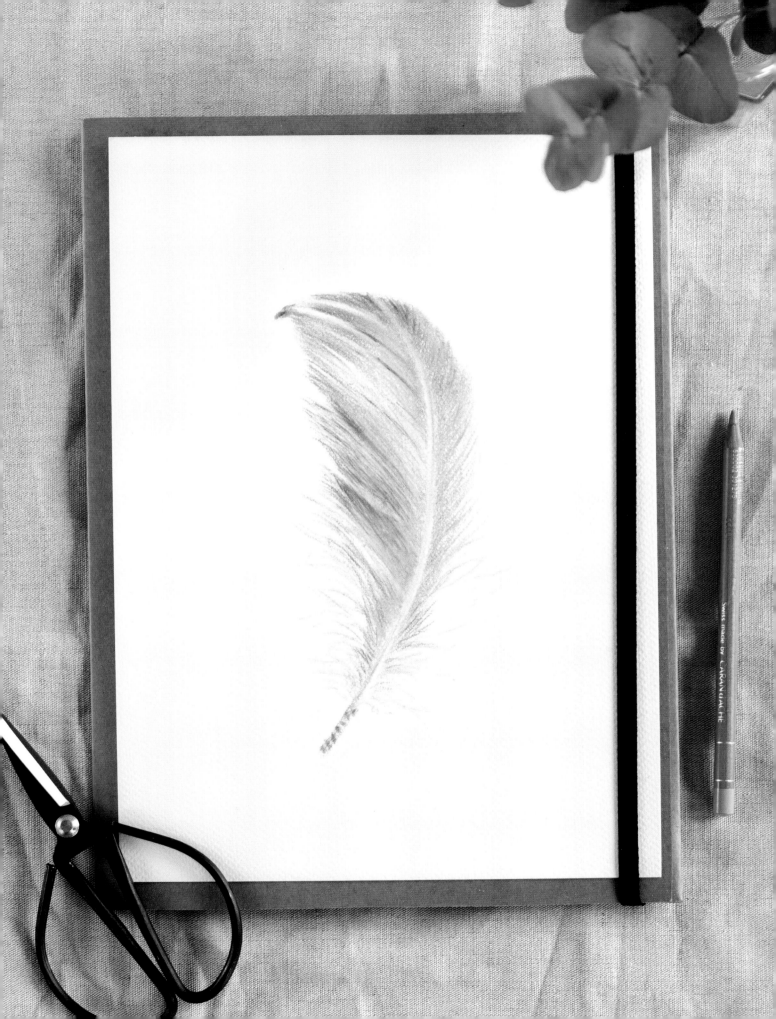

1 First, get the hollow central shaft of the feather in place. Use a base of Warm Grey 1, followed by a layer of Ivory to give the structure a warmer tone. Using Warm Grey 3, add the tiny shadows and details to the base of the hollow shaft. Draw small rectangular and triangular shapes that gently ascend the bottom part of the feather up to where the soft feathered part starts.

2 Using light pressure, add a light layer of Warm Grey 1 over the entire vane of the feather, taking care to follow the direction of the feathers outwards from the hollow middle. On the left-hand side, follow the feather structure towards the upper left, and on the right-hand side, to the upper right. Use tapered lines for the fluffier feathers towards the bottom. Lift your pencil towards the end of a stroke so that you get a nice flick of the line. Overlap your lines here to create a deep, almost tangled, mess of light feathers.

3 Working over the entire feather, add a light layer of Skyblue to enhance the white features. Now, go in and define the shadows. Make sure your pencil is sharp, that you use a light pressure and that you start from the top, using Warm Greys 2 and 3 to draw in the shadows that will give the feather structure and detail. If there are any partitions in the feather, add them in with Warm Grey 5 and blend out with Warm Grey 1.

4 Continue to darken the shadows, adding in layers of Skyblue and Earth Green among the grey tones. This will help to give a natural look to the shadows and prevent them from looking too grey or muddy.

5 Finish the feather off by using a white pencil to draw in small lines of detail and to define the central hollow shaft. You can also use the white pencil to blend the feather to achieve a smooth, sleek finish. Continue to darken shadows where needed to maintain the contrast within the piece.

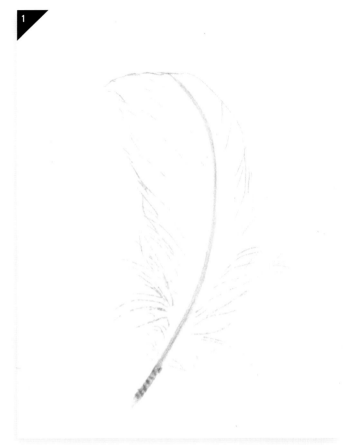

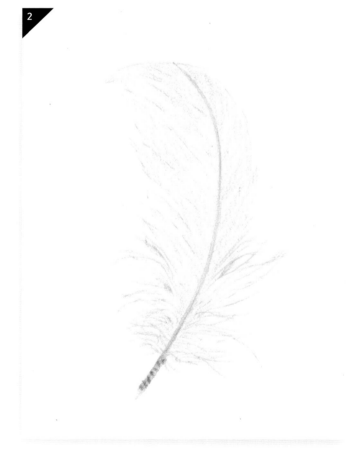

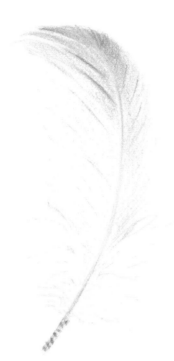

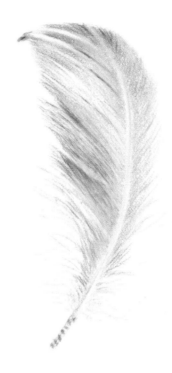

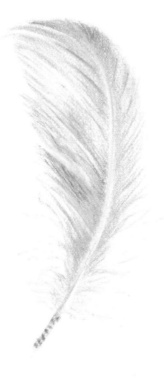

TIP

The shading on this feather includes blue and green tones. Adding these into the darker tones helps to give more life and depth.

Parrot's Beak

—

For this project, we will be using a solvent blender to produce the smooth texture of a beak. Using a solvent will help with adding white highlighted areas over dark, which is useful for the layered, sometimes cracked, appearance of beaks.

YOU WILL NEED

Pencils

Warm Grey 1 (270)

Warm Grey 3 (272)

Dark Sepia (175)

Cold Grey 6 (235)

Dark Indigo (157)

Skyblue (146)

Van Dyck Brown (176)

White

Other tools and materials

Solvent pen or blender pen

1 Start by layering Warm Grey 1 over the entire beak. This will serve as a good base for adding darker colours and blending with solvent. Add in the darkest parts of the beak using Dark Sepia, following the contours of the beak where it meets the bird's head. The key with layering is to follow the curve of the beak. Take note of how the different parts of the beak fit together and make sure your shading is smooth and light.

2 Darken the beak using layers of Warm Grey 3, Dark Sepia, Van Dyck Brown and Dark Indigo. The lower beak tends to be the darkest so just layering the darker colours there is fine. The top section of the beak has a few more highlights so start with lighter colours and gradually get darker. Skyblue will help to add to the brightness of the highlights. The aim is to layer up to about five colours so that they blend well with a solvent. Don't worry too much about the highlights because they can be added back in with a white pencil later.

3 Blend all areas of the beak using a solvent blender. I used a blender pen here because they allow greater control over the amount of solvent you use. If you're using a brush, wipe as much excess solvent off as you can before you start – maybe blot on a piece of paper towel – and make sure to blend the lightest sections first and then move onto the darker areas.

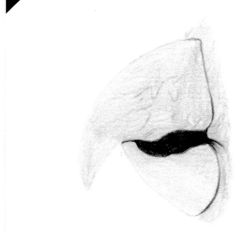

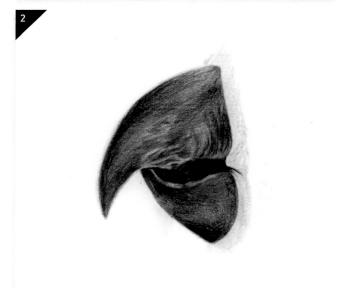

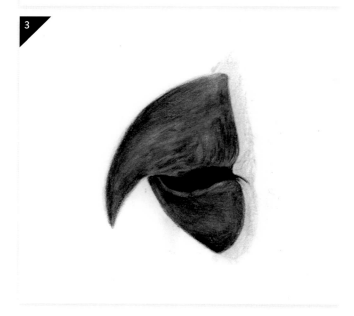

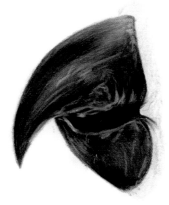

4 After blending with the solvent, build up the colour on the lower beak even further, with layers of Dark Indigo, Dark Sepia and Cold Grey 6. You should also be able to apply lighter colours easily, so fill in small, white details with a white pencil. You may need to use some pressure, but the white will show up well after solvent blending.

5 Continue in the same way as you did for step 4, working on the remainder of the beak and carefully taking note of dark and light tones. Once again, add in lighter tones and details with a white pencil to provide that high contrast.

TIP

The cracks and crevices really make the beak and give it texture, so pay close attention to any dark ridges or highlights to help bring the beak to life. Follow the curve of the beak with these lines and highlights, too.

TECHNIQUES USED

- Shading
- Layering

Parrot's Eye

—

Most bird's eyes are black with a hint of brown, but this project features a coloured eye as they tend to be more difficult to draw. The area surrounding the eye is the same on most birds and requires a few thoughtful shapes to complete it, along with a good amount of shading.

YOU WILL NEED

Pencils

Warm Grey 1 (270)

Earth Green (172)

Red Beige (132)

Black (199)

Nougat (178)

Warm Grey 4 (273)

Juniper Green (165)

Green Gold (268)

Dark Sepia (175)

White

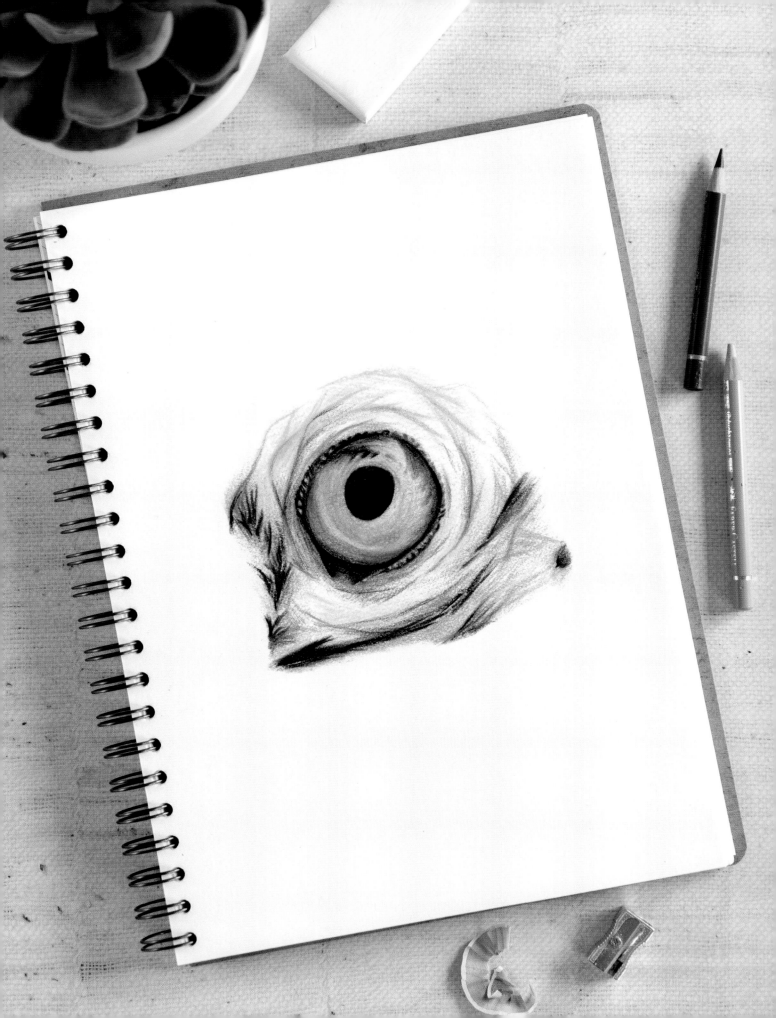

1 With a sharp Black pencil, start by gently outlining the iris and pupil to get the general shape in place. Once you're happy, you can fill in the pupil using small circular motions to fill the tooth of the paper. Use a little more pressure for the outer line of the eye. Fill in any dark areas around the outside of the eye, too. Add a layer of Warm Grey 1 directly around the outside of the eye – this will start to form the raised area that surrounds the bird's eye. Put down the dark feathers surrounding the eye, using Warm Grey 4 to gently flesh out their shapes.

2 Fill in the outer eye using Dark Sepia, creating a sort of 'n' shape above the eye and a 'u' shape below the eye. Shade them with Warm Grey 4 and Dark Sepia so they look less like the original shapes and more natural. If necessary, blend over them with Warm Grey 1. Form the wrinkles around the eye using Red Beige. Pay attention to the reference material and use light pressure to gently add intersecting lines. We'll define these more in the following steps.

3 Add a layer of Warm Grey 1 over the entire remaining area, taking care to shade and follow the direction of the feathers. Add a soft layer to the iris and follow this with a layer of Earth Green. Using the same shade, start to define the shadows and highlights within the eye by first outlining the highlight shape and then adding shadow around it.

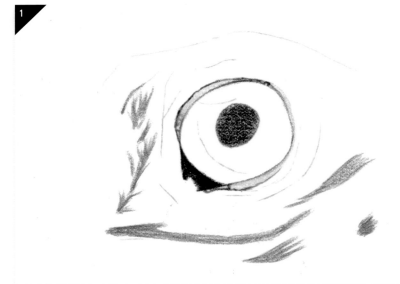

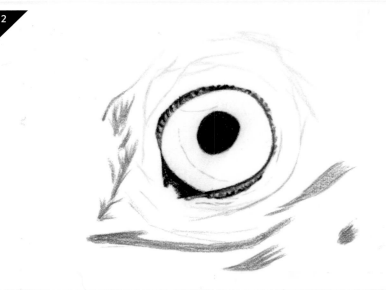

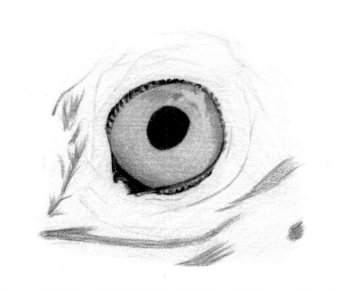

> **TIP**
> Bird's eyes often hold less detail than other animal's eyes, but remember to keep everything smooth, using small circles to create that glassy effect.

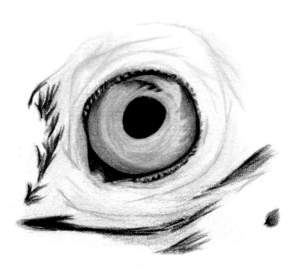

4 Continue working on the iris by layering more Earth Green into the shadows, followed by Juniper Green in the darkest parts – which tend to be around the highlight. Fill in the pupil with another layer of Black to help maintain a really strong contrast between that and the iris. To give depth to the shadows, add light layers of Green Gold and Nougat, paying particular attention to the outer edges of the iris. Use Dark Sepia to darken around the highlight in the eye if necessary. Add a little texture into the eye by creating arcs of Warm Grey 1 that follow the curve of the pupil. This helps to add dimension and interest.

5 Darken the feathers on the outer edge with some Dark Sepia and add a little shading around them using Warm Grey 4. Using firm pressure, darken the wrinkles on the skin around the eye with Red Beige. Also use Red Beige to shade around the outside of the wrinkles to help soften and blend them. Use Warm Grey 4 to gently shade around the very outer edge of the eye and blend with Warm Grey 1.

6 Continue to darken and shade the skin surrounding the eye with Red Beige and Warm Grey 4, really focusing on either side of the wrinkle lines and leaving a gap of lighter colour between two lines. This will help to achieve a concave look, as if the wrinkles are folding in on themselves. Shade the darkest parts right next to the wrinkle line and gradually get lighter as you approach another wrinkle line. You can see this effect properly on the top left-hand side of the piece. Give the dark feathers another layer to make sure the contrast is rich and adjust any of the shadows you feel need it. At this stage you can also use a white pencil to improve highlights and to help blend any of the colours together.

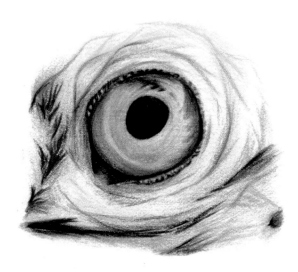

Parrot

—

Birds are one of my favourite things to draw because you get to use such bright, vibrant colours. I've incorporated the previous projects Bird's Beak and Bird's Eye into this drawing to get started and then focused on how to render feathers and how to blend colours together to create a seamless transition.

YOU WILL NEED

Pencils

- Warm Grey 1 (270)
- Warm Grey 4 (273)
- Cold Grey 5 (234)
- Dark Sepia (175)
- Black (199)
- Warm Grey 5 (274)
- Dark Indigo (157)
- Indanthrene Blue (247)
- Ultramarine (120)
- Skyblue (146)
- Light Cobalt Turquoise (154)

- Helio Turquoise (155)
- Juniper Green (165)
- Permanent Green Olive (167)
- Earth Green (172)
- Green Gold (268)
- Light Chrome Yellow (106)
- Dark Cadmium Yellow (108)
- Cadmium Orange (111)
- Coral (131)
- Caput Mortuum Violet (263)
- White

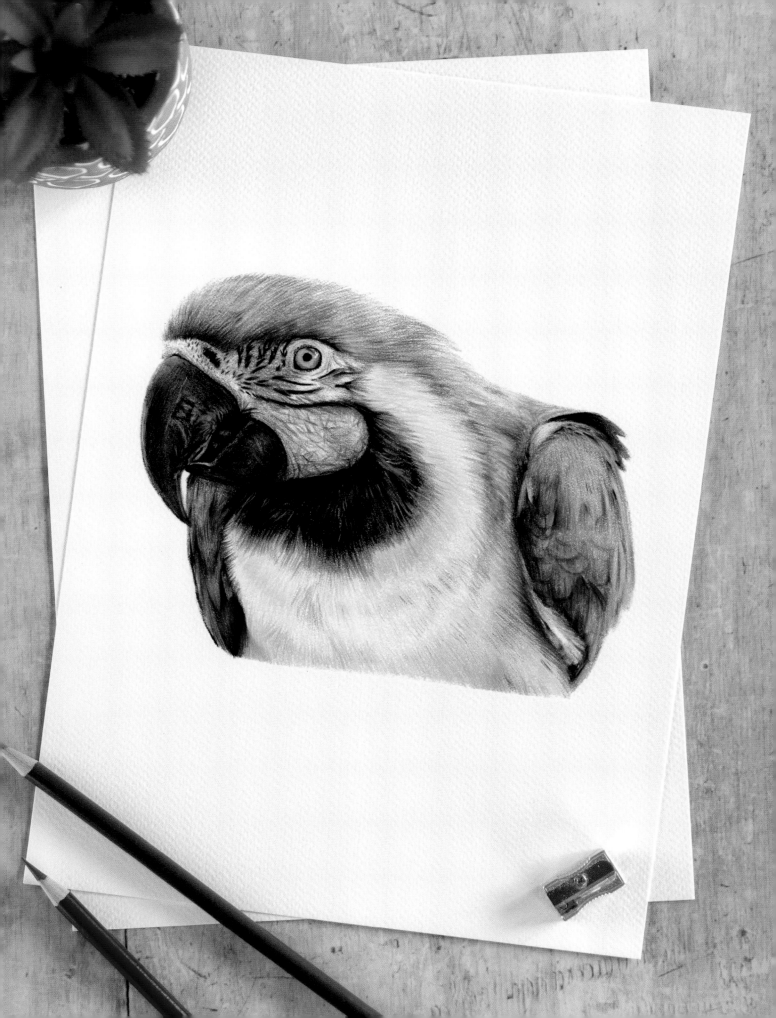

1 To start, draw the beak and eyes following the same techniques and using the same colours described in the Parrot's Eye and Parrot's Beak projects but on a slightly smaller scale. Use the same techniques and layering of colours, just make them smaller.

2 Start by filling in the dark feathers on the face using Warm Grey 4. Use light pressure to map in the contours and then go back over them with a second, firmer layer to solidify the feathers and shapes. After this, add a layer of Warm Grey 1 to the entire skin area, taking care around the darker feathers to minimize smudging and transference of colour to the lighter skin area.

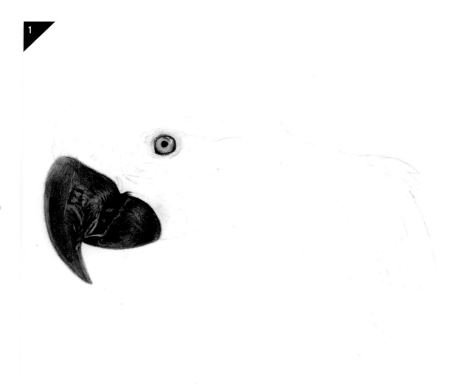

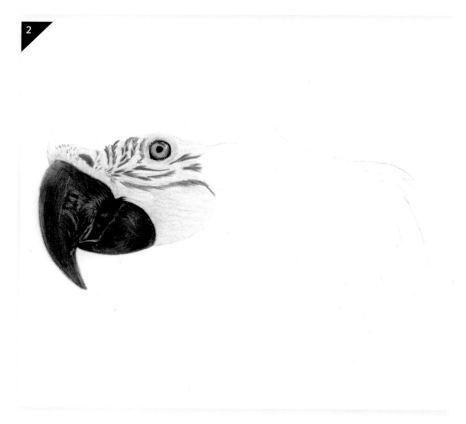

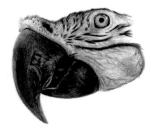

3 Use Warm Grey 4 and Coral to define the wrinkle lines on the skin around the eyes. Use a light hand when adding these so that you can make them gradually darker in places that need it. Use Warm Grey 1 to gently shade either side of the wrinkle lines, introducing Warm Grey 4, if necessary, to create a more three-dimensional form.

4 Use a light hand and a gentle shading motion to fill in the feathers on top of the head with Earth Green and Light Cobalt Turquoise. Make sure you follow the feather direction, which moves slightly up and off to the right. Add a little Earth Green into the blue to create a seamless overlap. In the same way, fill in the dark feathers on the neck using a base layer of Warm Grey 4. Use the same technique as for the top of the head and follow the feather direction. This time the feathers are flowing downwards and follow the curve of the face as they come round. You now have a good, light base for other layers and some of this layer will serve for the lightest feathers.

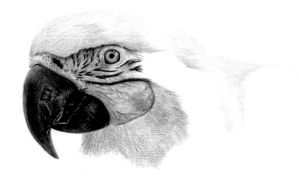

TIP

Birds often have a lot of different feather textures so make sure you use different techniques for each type of feather to differentiate them.

5 Using Dark Indigo, draw in the darkest, shadowed feathers, where the wings meet the body. Add in any of the darkest spots that you can see within the blue-toned feathers. Now, using Light Chrome Yellow, fill in the breast of the bird using the same light shading motion and following the direction of the feathers. If there are any feather direction changes, shade a little more to create a shadow where the changes take place.

6 Start refining the head feathers, first the green, adding a light layer of Light Chrome Yellow to accentuate the green tones of the base layer. Shade in another layer of Earth Green to help strengthen the green tones. Using Permanent Green Olive and Juniper Green – alternating between the two – draw small, fur-like lines that follow the direction of the feathers to build colour and depth. You can also layer in a few strokes of yellow and Earth Green here. Add the darker Juniper Green into the shadows, increasing the pressure a little. To darken the top of the face, layer Caput Mortuum Violet with the green to create a natural looking shadow. Darken the black area around the neck with another layer of Warm Grey 4 and fringe the edges where they meet the yellow breast with Juniper Green. Use a light pressure and a gentle shading motion to fill in the wings with a light layer of blue.

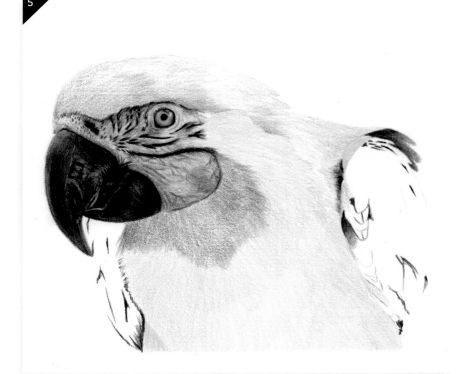

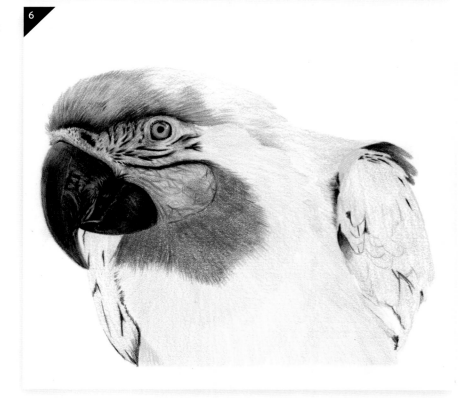

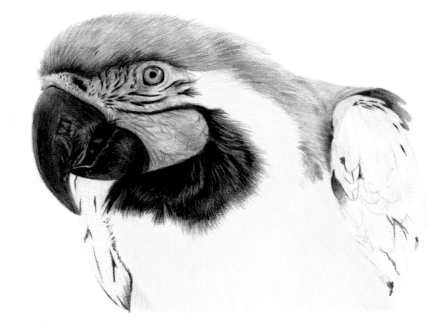

7 Continue working on the feathers on top of the head by layering in Skyblue, gently shading and adding it into the darkest blue areas. Layer some Ultramarine on top of this, creating small, fur-like lines to convey the soft, downy texture of the smaller head feathers. Use a layer of Dark Indigo to add shadows between some of the lines, taking care to keep this colour very sparse – add it only where you can see shadow. Refine and darken the neck by adding a layer of Cold Grey 5, blending every now and then with a white pencil. Use increased pressure in the darkest parts and leave the Warm Grey 5 showing where there are highlights. Next, go over the shadows and darkest areas using Black, blending into the slightly lighter tones by lifting the pressure from the pencil. Use a little Juniper Green and Dark Indigo to increase the depth of the black. Enhance the highlights of Cold Grey 5 with white and add in a few, hard-pressure strokes to pick out the brightest highlights.

8 Starting with a light layer of Light Chrome Yellow, add the feathers to the breast. Follow the direction of the feathers and use a short shading motion to mimic the short breast feathers. Use Dark Cadmium Yellow to add the shadows of the feathers, focusing on the area beneath the wings and underneath the dark feathers of the neck. Layer some Cadmium Orange on top and use Dark Indigo to create an even darker tone where needed. The bulk of the breast is light yellow and only gradually gets darker as the chest recedes back under the wings, so you want a nice gradation of colour from light at the top, down to darker at the bottom. If you need to blend, use Light Chrome Yellow paired with Coral to create a peachy red tone, which is great for adding into the shadows.

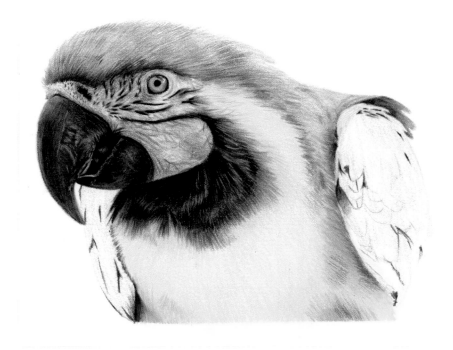

9 Continue to darken the yellow by adding more layers of the shades used in step 8, really layering them up and creating rich yellow tones. Now start dividing up the feathers into small scallop-shaped sections. To do this, use Green Gold to draw some small, tapered lines close together to form small 'U' shapes. Start with light pressure to get the shapes in place, paying close attention to the direction and width of each of the feathers. Take your time and work on them one by one. Add in darker tones of Juniper Green and Earth Green to enhance the shadows of the yellow. At this stage, also layer more Juniper Green over the yellow coming from the black neck of the parrot to create an overlapped effect.

10 Now shade the wings. Start by defining the darkest shadows around each of the feathers with Dark Indigo (see the right wing). Next, shade over a layer of Skyblue and Light Cobalt Turquoise. Pay attention to where there are slightly differing shades. The Cobalt Turquoise should be added to slightly more green-toned areas. Take care to overlap these two colours to create a smoothly blended base. Darken up the shadows by introducing the mid-tone blues, Helio Turquoise and Indanthrene Blue, to them. The wings are darker the further down you go, so concentrate on getting darker tones at the bottom and leaving the tops of the wings a little lighter (see the left-hand wing).

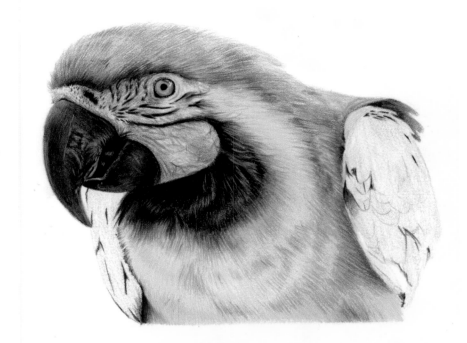

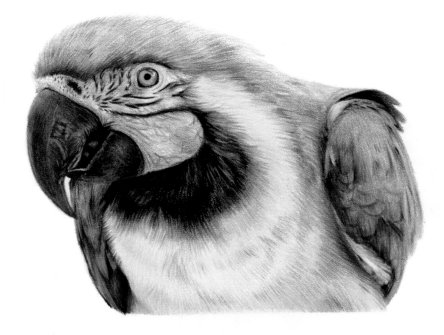

11 Blend the wing feathers using the lighter blue tones and gradually go darker around each of the feather sections using Indanthrene Blue and Helio Turquoise. Use firm pressure in the darker areas and lift the pressure as you work towards lighter areas. The area directly around the outside of a feather will be the darkest and this blends down into a lighter area at the tip of the feather layered beneath. In this way, fill in all the noticeable feathers on the wings. For smoother areas, make sure there are nice, smooth gradations of colour and a little texture created using small tapered lines in scalloped segments, like the texture added to the breast of the bird.

12 Finally, now that the wings have been added, refine and darken any colours. It will be a lot easier to judge the depth of tone with all the sections in place. Make any adjustments you feel necessary, focusing on ensuring the contrast between light and dark is correct.

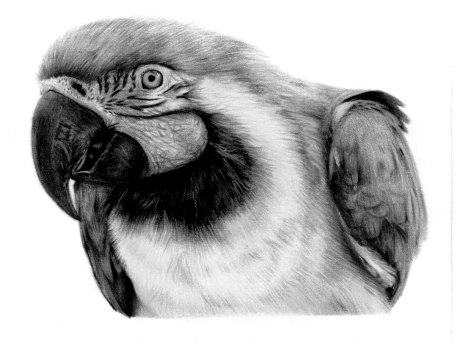

TECHNIQUES USED

- Shading
- Layering
- Glazing

Eye

—

I love spending time making sure that the eyes I draw are 100 per cent correct, look glassy and reflective and are as realistic as possible. Paying close attention to details, shadows and highlights is the key to creating this effect. Use a circular motion with your pencil to fill the tooth of the paper and add lots of layers to create depth.

YOU WILL NEED

Pencils

- Dark Sepia (175)
- Ivory (103)
- Burnt Sienna (283)
- Cinnamon (189)
- Walnut Brown (177)
- Beige Red (132)
- Warm Grey 3 (272)
- Skyblue (146)
- Venetian Red (190)
- Burnt Ochre (187)

- Caput Mortuum Violet (263)
- Black (199)
- Green Gold (268)
- Warm Grey 1 (270)
- Dark Indigo (157)
- White

Other tools and materials

White gel pen

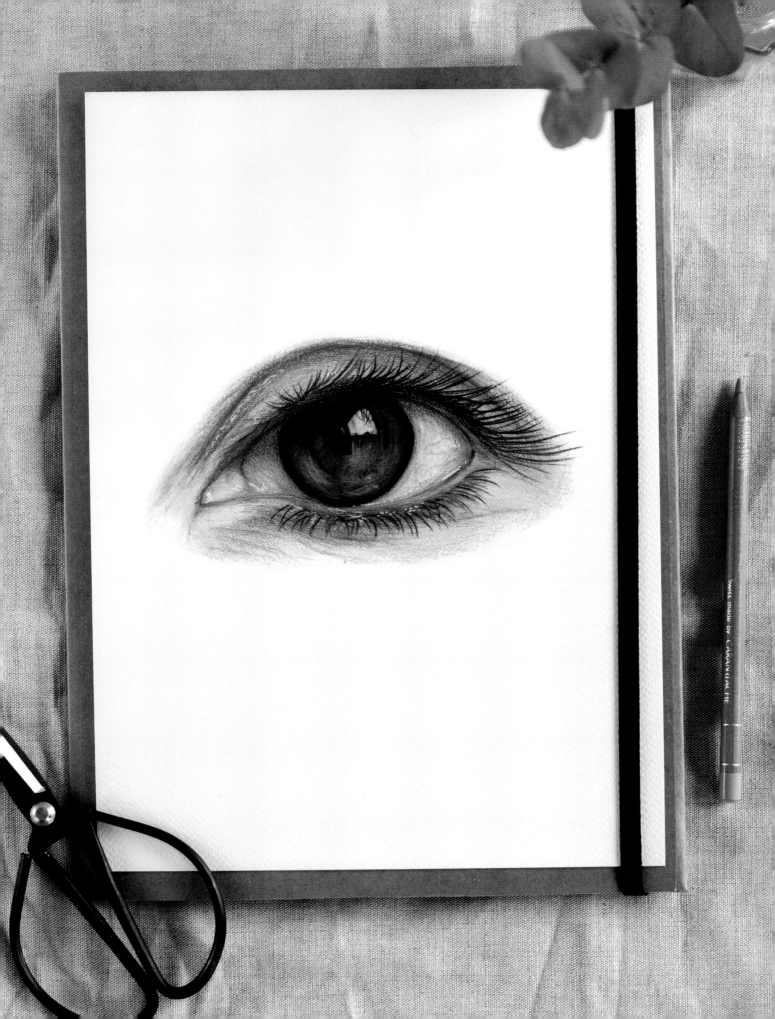

1 Define the darker areas within the eye by outlining the pupil and the very outer rim with Dark Sepia. Make sure your pencil is sharp and use light pressure to map the shapes in. When you're happy, use a little more pressure to solidify the line and fill in the pupil. Only fill the pupil up to and around any highlights. Using Beige Red, take the same approach to outlining the skin around the eye and defining the eyelid creases. Make sure to get the oval shape and the tear duct in place. Use Beige Red to outline any highlights on the skin. Using a circular pencil motion, fill in the cornea and iris. Shade the cornea with Warm Grey 1 and shade the Iris with Ivory.

2 Fill in the colours of the iris using Beige Red, Green Gold, Burnt Sienna and Burnt Ochre. Start with the lightest colour and add it where there are the lightest brown tones, then gradually get darker and layer the colours until you've filled the entire iris. You should have a dark outer ring and shading above the pupil. At this point, fill in the tear duct and waterline with a layer of Ivory, followed by Beige Red and then, using a firm pressure, define some darker areas around the tear duct and waterline.

3 Continue to darken the iris by layering on Walnut Brown, Burnt Sienna and Burnt Ochre to really saturate the colours. Add Dark Indigo around the edges of the iris and into the shadowed area at the top to deepen the colour. This will also be added to the whites of the eye, so it will tie in nicely. Blend the iris with Ivory to smooth everything out. The look you want is smooth and glassy. Making small circles with your pencil is key to achieving this.

4 Using Warm Grey 3, fill in the shadows of the whites of the eye, focusing on the eyelids and the area around the iris. Follow this with some Skyblue, blending the Warm Grey 3 and Skyblue together in the darker shadows. The aim is to really darken up the white of the eye – don't be afraid to go darker even though the anatomy is 'white'. There are lots of other colours in there and this part of the eye is darker than you think. Use Beige Red to add in a few veins and other details to the whites and layer a little Green Gold into the outer eye corner. Layer some Warm Grey 1 into the highlight of the eye, followed by Skyblue. Focus a heavier pressure of blue on the edges of the highlight to make the middle appear the brightest. Add any reflections, such as eyelashes or scenery, that may be in there using sharp pencils to really get the details down.

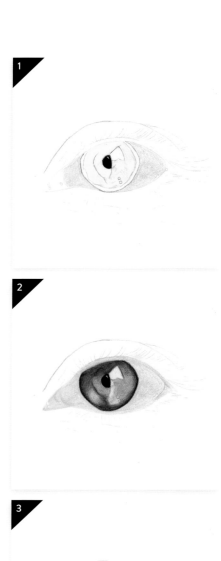

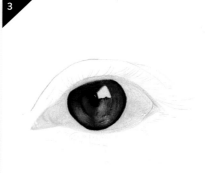

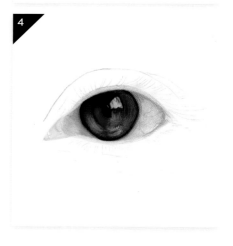

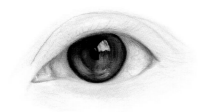

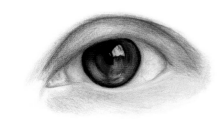

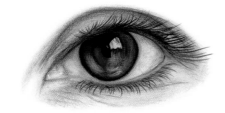

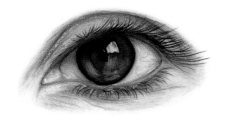

5 Use Ivory as a base layer for the outer skin of the eye, using small circular motions to create a smooth surface. Follow this with a light layer of Beige Red to create a basic skin tone. Repeat the second colour, slightly increasing the pressure on the pencil to create darker tones. Darken the tear duct and waterline a little more by adding in a layer of Venetian Red and Caput Mortuum Violet. Shade these colours lightly and, if needed, blend together using the Ivory. If you need to darken the tone even further, add in light layers of Dark Indigo, blending with lighter colours in-between to help create a smooth look.

6 Darken the shadows of the skin with Layers of Cinnamon, Burnt Ochre and Venetian Red. Use light layers of each and make sure you check your reference material after each to see where you need to go darker. Use Caput Mortuum Violet, Dark Indigo and Walnut Brown in the eyelid creases to create smooth, dark shadows and lightly blend these into the lighter skin tones by gradually lifting the pressure from your pencils. Leave the highlights free of any further colour and focus on getting darker in the places that need it.

7 Continue to adjust and darken the skin around the eyelids and add in fine lines with a darker tone, such as Venetian Red, really paying attention to those dark shadows. It's important to get all the undertones of the skin in before adding the eyelashes, which is what we'll do next. With a sharp Black pencil, draw in the eyelashes, taking care to follow the direction and length according to where they are on the eye – shorter ones towards the inner eye and longer lashes towards the outer eye. Lift your pencil from the paper as you move it towards the end of an eyelash to get that smooth, tapered look. Make sure you leave a gap for the waterline on both eyelids.

8 This final step is all about refinement and glazing the colours to help the shadows and tones. Use a very light touch and hold your pencils on their sides to add subtle, light colour that enhances shadows and colours over the entire subject. You could use a white gel pen or white pencil to add in highlights along the waterlines and inner eye corners, along with subtle highlights on the skin and between the lashes.

TIP

Take care to position the roots of the eyelashes correctly. They don't come from the whites of the eye or the waterline but just below.

TECHNIQUES USED

- Shading
- Layering
- Blending

Lips

—

Lips, especially glossy ones, are one of the more fun things to draw. They're also one of the hardest, as you need to make sure you get the shadows in the right place. The lips in this project are slightly parted and shown slightly from the side so you can see how the shadows fall in this situation. A white gel pen is used to create the brilliant shine.

YOU WILL NEED

Pencils

Dark Red (225)

Dark Sepia (175)

Rose Carmine (124)

Pink Carmine (127)

Cinnamon (189)

Light Magenta (119)

Magenta (133)

Pink Madder Lake (129)

White

Other tools and materials

White gel pen

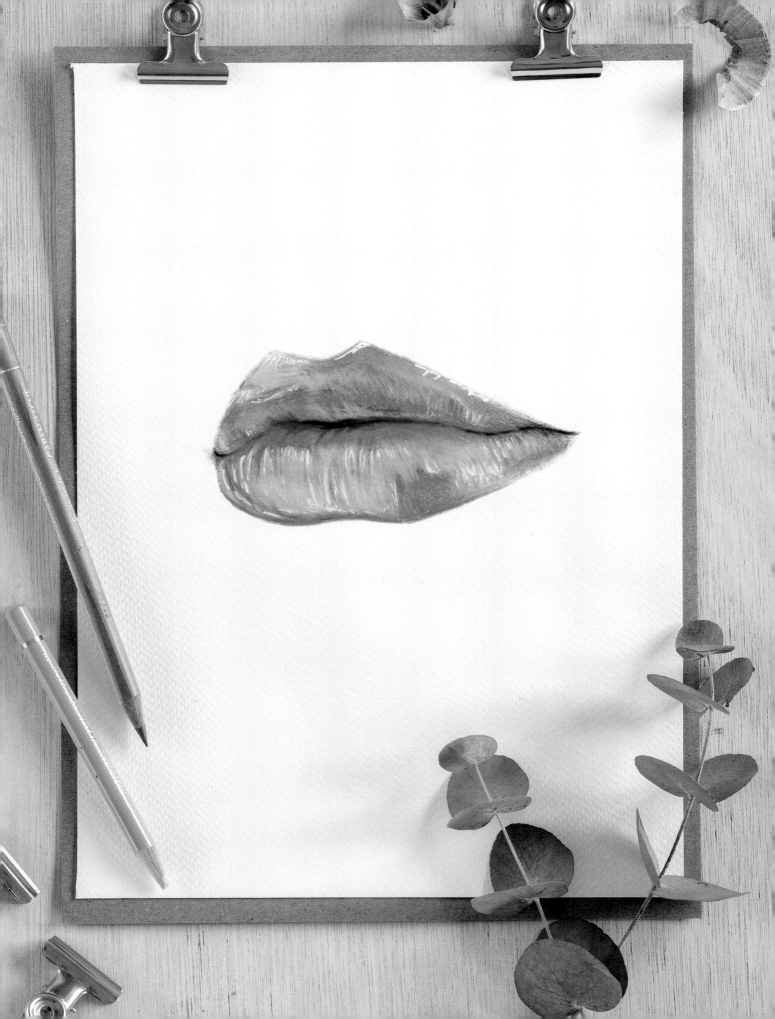

1. The darkest area in this image is where the lips meet and are slightly parted. Start by defining the darkest area using Dark Red followed by a light layer of Dark Sepia to darken even further.

2. Add in the mid-toned areas using Rose Carmine, using a soft shading motion and paying attention to where these tones meet lighter ones and highlights. The majority of the bottom lip is made up of light tones and highlights, whereas the top lip is mainly shaded. Add multiple layers for the ever-so-slightly darker areas and shade a little more heavily around the existing shadows.

3. Darken the mid tones on the upper lip using Pink Carmine before adding a light layer of Cinnamon all over, followed by a light covering of Light Magenta. These lighter tones will fill in the blank spaces left previously and will become the highlights in the upper lip. Once you've got a decent amount of coverage, use a white pencil to blend and smooth everything together, especially in the lighter tones. Darker tones may not need to be blended with the white. Blending will help increase the light values and make them pop against the darker values.

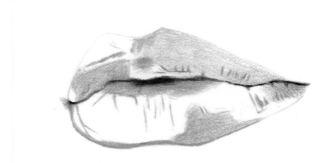

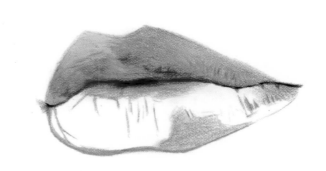

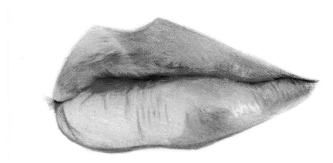

4. Fill in the lower lip in the same way as you did the top, gently shading some of the darker patches before going over them with the lightest colours. I also added a little Pink Madder Lake into the large, main, highlight to give it a little more body. As before, use the white pencil to blend the lip. Follow the curve of the lip when blending as it makes subsequent layers easier to put down.

5. Continue to darken and blend the lower lip, adding a few more layers onto the highlight using Light Magenta and Pink Madder Lake. Dark Red is really useful in creating a soft blend from where the lips meet towards the highlight. Start with a heavier pressure and then gradually ease the pressure from the pencil as you work towards the highlighted area. The highlight is best left with quite blunt edges – this will help to give the impression of high shine. There are some areas that are softly blended and transitioned, so pay attention to these and use a light pressure when applying your pencil. Using Magenta, add in a few detail lines along the centre of the lips. Keep these lines light at first and darken them gently where needed.

6. Make small adjustments to the lips and add in layers of white pencil to create a translucent sheen across some areas. This helps to create the impression of gloss sitting on top of the actual lip. Keep layering and blending to create as smooth a look as possible while retaining the saturation of colour and those glossy lines. Finally, use a white gel pen to add in areas of high shine, breaking up some of the shine to give the hint of a little lip texture. For the large glossy area, create a few highlights running along the detail lines and follow any curves of the lips with the gel pen.

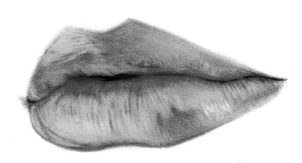

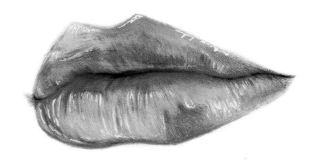

TECHNIQUES USED
- Shading
- Layering
- Blending
- Glazing

Hair

—

When drawing hair, it's really important to make sure the contrast is right and that the direction of the hair in each section is correct. Hair tends to fall in sections that flow in slightly different directions, or when styled, sections can be worked in completely different directions.

YOU WILL NEED

Warm Grey 1 (270)

Cinnamon (189)

Skyblue (146)

Dark Sepia (175)

Burnt Sienna (283)

Caput Mortumm Violet (263)

Walnut Brown (177)

Sanguine (188)

White

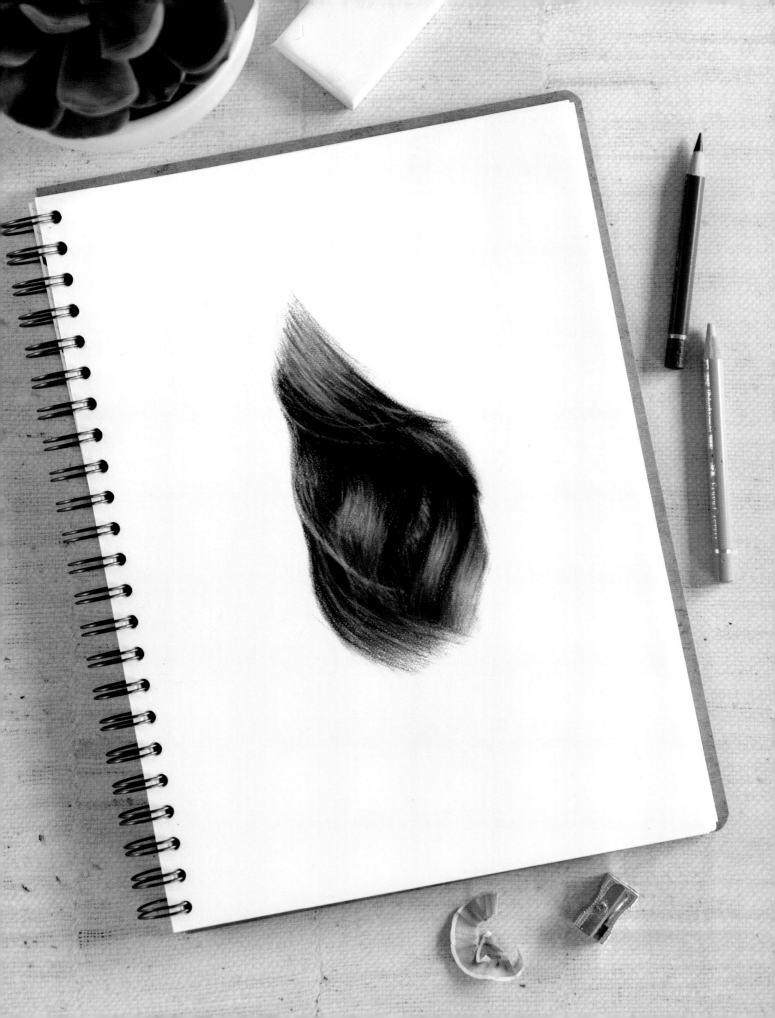

1. The first step in rendering hair is to create the shadows and divide the hair in terms of sections, instead of individual strands of hair. Look at where the different sections overlap or change direction and shade around these areas using Walnut Brown. Generally, the darkest sections of hair will be those in the background, or those overlapped by other sections.

2. Now fill in the base tone using Warm Grey 1, this is what will become the shiny, glossy parts of the hair or the highlights. Other colours will be added to this base to create more three-dimensional clumps of hair. Shade Warm Grey 1 all over, working in the hair sections that you defined previously.

3. Start to add depth to the hair by building up the mid tones using Cinnamon – work it into the existing dark tones, too. This will add warmth to the hair. Stay clear of the highlights with the Cinnamon and instead, add a light layer of Skyblue to them. This will help to add to the shine of the hair. Use Dark Sepia to darken the existing dark areas and use soft tapered lines to blend the darker areas into the lighter sections of hair. Remember to work in sections of the hair and in the direction the hair is flowing.

4. Add more depth to the mid tones using Burnt Sienna and gently layer it into the dark sections, also working out towards the lighter sections with those soft tapered lines. You could also use more Dark Sepia to darken the shadows even further.

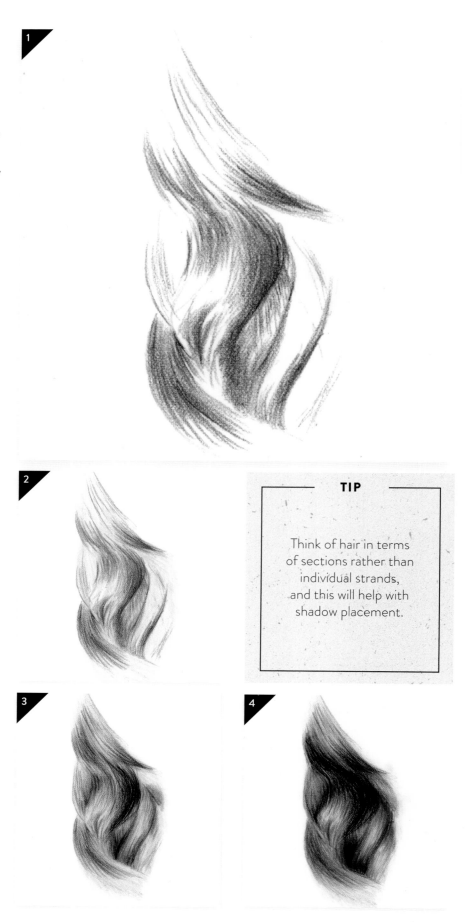

> **TIP**
>
> Think of hair in terms of sections rather than individual strands, and this will help with shadow placement.

5

6

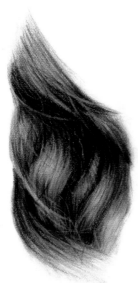

7

5. Further define the darker areas using a combination of Caput Mortuum Violet, Walnut Brown and Dark Sepia. Focus on creating darker edges and leaving the middle of the hair sections the brightest, to give the impression of shine. Use Cinnamon and Warm Grey 1 to work back into the highlights and blend them into the darker sections. To do this, work from the middle of the highlight outwards into the shadows. Use Sanguine to add a little more depth to the mid tones and layer on a little more Burnt Sienna.

6. Add details, like fly-away hairs and strands, using a sharp, white pencil. Adding fly-away hairs in this way adds to the realism and depth of the hair and it's important to add them not just in the direction of the hair, but also overlapping and falling in several different directions to really convey the structure of the hair. You can also use a Walnut Brown or Dark Sepia pencil to add the dark fly-aways, too.

7. To finish, make minor colour adjustments using the glazing method, adding Burnt Sienna, Sanguine and Caput Mortuum Violet, mainly into the shadows, and ever so slightly into the highlights if you feel it's needed. You want to get maximum contrast between the highlights and shadows, so make sure that these values are accurate. If necessary, add in a few more fly-away hairs, glazed slightly with the mid-tone colours to help tone the white down.

About the author

Amie Howard has worked with coloured pencils for many years. She started her art journey as a pet portrait artist. Amie has always loved animals and her childhood dream was to become a vet – so drawing pets felt like a natural choice. She has since branched out into wildlife art, recreating some of her favourite wild animals on paper.

Amie is deeply inspired by nature and is fortunate enough to live close to the sea and woodlands, from which she draws a lot of inspiration. Birds feature a lot in her work and on warm days she leaves the studio door open so that she can hear the birds singing.

Amie's husband and son often accompany her on trips to the harbour or the woods for long walks, where they gather feathers, sticks and other natural objects, which frequently find their way into Amie's work.

Acknowledgments

First, I would like to thank the wonderful team at David and Charles for the opportunity to realize one of my biggest dreams. Sarah, Jess and Lindsay have given so much direction that helped make this book possible.

To all my friends who have given their time to listen to me ramble (a lot), talk through ideas and lend their cats and other various things for the projects in the book: you guys have really helped me through this – sometimes frustrating – process.

And I'll be forever grateful to Puddy and Mabel for being fantastic cat models.

Finally, thank you to my husband Simon and son James. Both of you have been so supportive. Simon, you have kept James entertained when I've needed to draw or write, and James thank you for being the unimaginably bright ray of light you always are. I don't think I'd have had the emotional strength to complete this project if it wasn't for your unwavering support.

Suppliers

I source nearly all my materials from the following suppliers. I mainly use Faber Castell Polychromos coloured pencils and all of these outlets can supply them. However, there are loads of other outlets to buy your materials from, so don't feel limited to the ones I've suggested.

JACKSONS ART SUPPLIES

www.jacksonsart.com

Jacksons Art Supplies is the place I always go to for imperial size sheets of Fabriano paper. They also stock a huge array of other brands.

COLOURED PENCIL SHOP

www.colouredpencilshop.co.uk

The Coloured Pencil Shop is a great place to get your Prismacolor pencils (if they're your favourite!) as well as the high quality, artist-grade pencils like Polychromos and Luminance.

CULT PENS

www.cultpens.com

Cult Pens have a wide variety of other art materials too, so if you're into using many different media, they have some great options.

GREAT ART

www.greatart.co.uk

I go to Great Art for fantastic deals on coloured pencils and other supplies. Coloured pencil sets from here are a favourite.

Index

A DAVID AND CHARLES BOOK
© David and Charles, Ltd 2022

David and Charles is an imprint of David and Charles, Ltd
Suite A, Tourism House, Pynes Hill, Exeter, EX2 5WS

ISBN-13: 9781446309322 paperback
ISBN-13: 9781446381809 EPUB
ISBN-13: 9781446381793 PDF

This book has been printed on paper from approved suppliers and made from pulp from sustainable sources.

Printed in the UK by Short Run Press for:
David and Charles, Ltd
Suite A, Tourism House, Pynes Hill, Exeter, EX2 5WS

10 9 8 7 6 5 4 3 2 1

Publishing Director: Ame Verso
Senior Commissioning Editor: Sarah Callard
Managing Editor: Jeni Chown
Editor: Jessica Cropper
Project Editor: Lindsay Kaubi
Head of Design: Anna Wade
Design: Sam Staddon and Laura Woussen
Art Direction: Sam Staddon
Pre-press Designer: Ali Stark
Illustrations: Amie Howard
Photography: Jason Jenkins
Production Manager: Beverley Richardson

Thank you to the photographers who supplied the images used as references for the following drawings:
Cat's Eye (Holly Kanter), Cat's Face (Daniel Reynolds), Dog (Rachel Pattison) and Dog's Nose (Tina Chapman)

David and Charles publishes high-quality books on a wide range of subjects. For more information visit www.davidandcharles.com.

Share your makes with us on social media using #dandcbooks and follow us on Facebook and Instagram by searching for @dandcbooks.

Layout of the digital edition of this book may vary depending on reader hardware and display settings.